LETTERS LIKE THE DAY

11-21-17

9:30 Sunday Night —

Jor just read your letter —
— looked at it — simply
glanced this morning — read
Elizabeths this morning twice and
again at noon but have just now
been free long enough to tackle
yours — It may be a large mixture of
many things but it is living and
real — and its curious how
we seem to be saying the same thing
so often — feeling the same —
Curious — yet not
curious

When I finished it —

how to tell you
how glad I am that this "scribbled
page" is come to me — so)

First page of letter from Georgia O'Keeffe to Alfred Stieglitz, dated November 21, 1917.
Sent from Canyon, Texas.

LETTERS LIKE THE DAY

On Reading Georgia O'Keeffe

Jennifer Sinor

UNIVERSITY OF NEW MEXICO PRESS • ALBUQUERQUE

Library of Congress Cataloging-in-Publication Data
Names: Sinor, Jennifer, 1969– author.
Title: Letters like the day : on reading Georgia O'Keeffe / Jennifer Sinor.
Other titles: On reading Georgia O'Keeffe
Description: Albuquerque : University of New Mexico Press, 2017. |
Includes bibliographical references.
Identifiers: LCCN 2016017253 | ISBN 9780826357830 (pbk. : alk. paper) |
ISBN 9780826357847 (electronic)
Subjects: LCSH: O'Keeffe, Georgia, 1887–1986—Correspondence. | Sinor, Jennifer, 1969–
Classification: LCC N6537.O39 S56 2017 | DDC 759.13—dc23 LC record available at
https://lccn.loc.gov/2016017253

Portions of "A Walk into the Night" first appeared in *Gulf Coast*. Portions of "Spiral"
first appeared in *Ecotone*. Portions of "More Feeling Than Brain" first appeared in
Fugue. Portions of "Taking Myself to the Sun" first appeared in the *Florida Review*.
Portions of "Perfectly Fantastic" first appeared in *Still Points Arts Quarterly*.
Portions of "Holes in the Sky" first appeared in *Seneca Review*.

Cover illustration: *Series 1, No. 8*, 1919. Oil on canvas, 20 x 16 inches. Georgia O'Keeffe
Designed by Catherine Leonardo
Composed in Minion Pro 10.5/14
Display font is Optima Lt Std and Callie Hand

For Michael, my shore

At the mail box—all my beautiful world like a ribbon in front of me.

—*Georgia O'Keeffe to Alfred Stieglitz, June 22, 1943*

CONTENTS

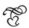

Dear Reader,

I don't know who you are. I have long imagined you, while writing this book, pictured you reading these essays in a kitchen or a classroom or at a bus stop in the rain. But I find that the closer I get to you the harder it is for me to see you as you really are. Not in terms of demographics—your age or your gender or whether you eat breakfast in the morning—but more in terms of your expectations. How much, I wonder, do you know about modernism? How long are you willing to sit with an essay and puzzle over it? What is your relationship to Georgia O'Keeffe or to the land or to letter writing? How about your tolerance for the unknown?

I don't have the answers to any of these questions and have actually stopped asking them. I realized that knowledge of O'Keeffe or art history or the challenges of contemporary essays doesn't much matter. Art must, if it is to succeed, provide multiple points of intersection and connection. It stands as a gathering place. Each of you, I am hoping, will find your way into the essays that follow. Every route will be different. Every reading, unique. I write this preface to share the story of how I became O'Keeffe's reader, how I made my own path into her words.

When I was fifteen, my mother took me to the National Gallery of Art. We had been in northern Virginia for almost a year by then, memories of our previous tour of duty in Hawaii dimming with the fall light. Each morning my father left in the dark to catch the Metro to the Pentagon. An hour later, I walked down the hill to take the bus to high school, where I crept the halls with two thousand other students. As a military family, we had moved a lot, but I don't think any of us were prepared for the leap across both ocean and continent.

The oldest of three children, I carry only a handful of memories of the days I spent alone with one of my parents. That spring day at the National Gallery, the cherry blossoms not quite unfisted on the Mall, is one I hold on to. My mother and I dressed up. I wore a blue skirt with a red straw hat and nude stockings that turned my

*already pale legs even paler. Together we walked past the paintings
and sculptures, stopping to read the descriptions next to the works.
For lunch, we ate salads and tiny sandwiches and drank iced tea
from narrow glasses freckled with condensation. At the end of the
day, we visited the gift shop so that I could choose a print to later
frame. I remember skimming through the options, trying to decide
on a reproduction that would capture the day, the time in my life,
my feelings.*

I chose Pablo Picasso's The Tragedy.

*Looking back, I can see all sorts of reasons for the appeal of that
print. I was a depressed teenager. I missed my friends. I worried
constantly about nuclear war. I hated my skinny legs and shiny
forehead. If asked, I would have said that my life was a tragedy. But
I also think I chose the Picasso print because it told a story. Three
figures: a man, a woman, and a child. Gathered on the beach in
tattered clothes. It was a story I recognized. Need and want. Also a
story of being marooned, abandoned, alone. I could invent any
number of romantic scenarios that had left this family bereft. At
fifteen, I believed in beginnings and endings, cause and effect, and
the tidiness of a narrative line. I also recognized that my life would
not always be a tragedy. I would go to college, fall in love, and live
happily every after. I was blue now, but my life would be a rainbow.
Just like* The Cosby Show.

*What I didn't see that day at the National Gallery of Art was the
power of abstraction. The modernists, with their elemental
approach, nonrepresentative form, and inscrutable titles like* Red
No. 1, *did nothing for me. How could lines and forms add up to a
story, one that I could enter, furnish, and inhabit? I can't tell you
how many paintings by Georgia O'Keeffe I passed by that day. The
National Gallery holds six of her Jack-in-the-Pulpit series from
1930—each blossom becoming less like a flower and more like an
answer—but I don't recall seeing one of them.*

*As one of the first American modernists, O'Keeffe could not have
cared less about the story a painting told. Even in her early attempts
at abstraction, her Specials from 1915, for example, she was in
pursuit of capturing in paint what could not be articulated in
words: the emotional truth of seeing. And that truth arrived through*

magnification, selection, simplification, and juxtaposition; it was
not heralded by "once upon a time." I overlooked it all.

Fast-forward twenty years—through a painful divorce at the age
of twenty-five, in which I gave up a husband as well as a happily
ever after, and then through a doctoral program, in which the idea
of a linear story became not only a lie but also a product of a culture
that silenced those who narrated their lives differently—to the day
my great-aunt handed me the diary of my great-great-great-aunt
Annie, a woman who homesteaded in the Dakotas in the late
nineteenth century. It was a ledger book really, not even a proper
diary. And when the ledger book ended, she wrote on any scrap of
paper she could find. I took the pages home and sat with them.

Unlike many diaries kept in the late nineteenth century, Annie's
diary is not one that most people would value. It is a bare-bones
document. Each day she describes the work she completed; the mail
she received; the travels of her husband, Charlie, an itinerant
blacksmith. Little of the scholarship at the time helped me read and
understand what Annie was up to. The diaries valued were those
that told stories—lovely accounts of full days, the comings and
goings, the drama of family life. Annie baked bread. Annie darned
socks. Annie mopped.

I spent many years learning how to read what Annie had left me,
writing I came to call "ordinary" because it did not have a beginning,
middle, and end. It did not tell a story. Rather it documented "time
in," not "time when." Spare, cropped, and elemental, her diary
taught me to value that which arrives "unread"—that is, writing that
does not sort itself into a tight, chronological story that we recognize
but rather undoes all our expectations and forces us to read
differently. Not unlike abstract art.

It should come as no surprise that at this moment I turned, or
maybe returned, to O'Keeffe. In 2000, just as I finished my PhD and
two years before I would publish The Extraordinary Work of
Ordinary Writing: Annie Ray's Diary, *I went to* The Poetry of
Things, an O'Keeffe exhibit at the Dallas Museum of Art. According
to the DMA website, "The exhibition explore[d] the way O'Keeffe
approached still life paintings from a modernist perspective." I
traveled her bones and flowers. I fell into her skies. And I never once

asked, "What is this painting about?" Instead, I sat with form and allowed myself to be called by color, opened by her way of seeing. In other words, just as the title of the exhibit prompted, and already tutored by the writing of a lonely and childless woman living on the plains, I approached each painting as a piece of writing, a poem. Metaphor. Association. Lyricism.

When I published my book about Annie's diary in 2002, I affirmed the link I was just beginning to intuit between writing and O'Keeffe by including a poem by Linda Hasselstrom, a North Dakota poet. Entitled "Bone," the poem is dedicated to O'Keeffe and her "polished jawbone[s]." What I saw in Annie's diary was the same thing I was seeing in O'Keeffe: the value of work that refuses to tell us how to read it and instead asks us to approach from our own emotional center.

In 2006, twenty years after her death, Georgia O'Keeffe's letters were released to the public. It would take me two years to come across the archive, but when I did, I knew I wanted to read them all. I began with her Hawaii letters, those she wrote to her husband, Alfred Stieglitz, during the eight weeks she visited the islands in the spring of 1939. Hawaii was just the start though. Once I began, I could not stop. Her letters pulse with a kind of energy and passion that is impossible to ignore. Visually, textually, emotionally, they called to me. I learned her handwriting, the slant of her line, the color of ink she seemingly preferred. I negotiated the empty spaces on her pages—not just the margins but in the body of the letters themselves. I rode her dashes between words and sentences, paragraphs, and ideas. I followed lines of ink that ended in spirals, lines of ink that became waves, lines of ink that turned into words. For several years I read the letters, and then I read anything I could about O'Keeffe. I stood on the rim of Palo Duro Canyon and under the bowl of a New Mexico sky. Then I went to Yale and held the letters in my hands.

But when I initially tried to write essays that responded to the letters, to move out from her language and into my own, I was paralyzed. Not by her stature as an artist or by her fame. Not by a lack of things I wanted to say. But because of O'Keeffe's own understanding of language and how words limit, corrupt, corrode.

In her letters, O'Keeffe articulated time and again her belief that language failed us more than it served. Paint was malleable in a way that text was not. And she distrusted language entirely.

I began to question the limits of language. Perhaps, I thought, the visual arts and music were the true art forms. Because they could be nonrepresentational, they could move past or through the mind and straight to the heart. The color blue was far more fluid than the word itself. There was only so much that could be explored on the page. As a writer, I had the twenty-six letters of the alphabet, a two-dimensional surface, and margins. I felt manacled by the very form I had dedicated my life to.

After much failure, I remembered Annie: how she moved words on a page, how she used her margins and space in a way that required a new kind of reading, how she challenged readers by her restraint and made them want to quit or ignore what she was doing. I remembered the rewards of finding a way through. Wasn't such an encounter at the very heart of modernism itself? Force viewers to reexperience what they thought they knew and understood. I saw it as a challenge. Could I apply the tenets of modernism, O'Keeffe's aesthetic in particular, to writing? Could I move away from narrative, cause and effect, and chronology and toward juxta-position, empty space, and nonlinearity as a way to translate the heart of a subject?

O'Keeffe's letters offered me the very subject for exploring the elasticity of language and writing. Passionate, wide-ranging, and exemplifying O'Keeffe's dedication to modernism in every facet of her life, they could withstand repeated forays. They could be painted again and again. Just as O'Keeffe did when she worked across a series—the same jack-in-the-pulpit over and over—I began to imagine the various ways I could turn my subject on its head, explode it across a series of essays that took the limits and possibilities of writing itself as the center.

What you hold in your hands, dear reader, is the result of that experiment in language. Nine essays that attempt to push words on the page as O'Keeffe pushed paint on her canvas. Nine essays that magnify, crop, and simplify their subjects to replicate what it means, for me as a writer, to really look. Some of them, such as "Perfectly

Fantastic," cleave closer to a narrative line, arrive more representational: a flower, a valley, a horse's skull. Others, such as "Holes in the Sky," resemble more closely O'Keeffe's Ram's Head, Blue Morning Glory, which gives us a ram's skull and a blue flower (with not even a conjunction in the title to connect them) and then asks us to bring them together. These nine experiments work as a series, taking as their subject the letters written by a central figure of modernism, who turned trees upside down and painted ladders to the moon. While the letters are the subject, writing is the center. In its own way, each essay asks the same question: How can I use words as O'Keeffe used pigment to convey an emotional truth?

My hope is that the essays I have written in response to this question create a vibrant space in which to gather and that they allow you to experience some of the delight and challenge that I have found in reading Georgia O'Keeffe.

Sincerely,
Jennifer Sinor

Letters Like the Day

ON JULY 10, 2013, sixty-seven years to the day after it was written, I hold the last letter Georgia O'Keeffe sent to her husband, Alfred Stieglitz. I am sitting in the reading room of the Beinecke Rare Book and Manuscript Library on the campus of Yale University. Outside, summer nears high tide. The elms hang full with leaves, and the sky, scoured by heat. Inside, though, filtered air circulates around the readers. We work in silence. No birds, no dogs or sirens interrupt us. In the basement of the library there is only the turn of a page, the scrawl of pencil, the shush as a medieval leaf falls to the table. In this stillness, this cooled and pressed silence, I begin to cry.

I had known I was nearing the end of their correspondence—one that spans thirty years and contains some nineteen hundred letters—but I was not prepared for the envelope. On the front, someone has scrawled, "found unopened—came too late." It is not O'Keeffe's hand. By now, I would recognize the gentle slope of her words anywhere. Someone else, most likely Doris Bry, lets me know that this letter was unsealed by someone other than Stieglitz, the intended, that maybe it sat for days in the mailbox in New York or sank to the bottom of stacks of papers on the kitchen table. A second envelope is also marked "came too late." When O'Keeffe's final two letters were postmarked in New Mexico on July 12, her husband was still alive. A day later, though, her letters just leaving Santa Fe, he was dead.

The last words he would have read from her were, "A kiss to you," the final line of a letter sent July 6, 1946. For three decades she had been sending him her kisses from the faraway, along with feathers, leaves, and flowers. Sometimes the night itself, the moon, the sun sent Stieglitz their salutations as well.

The silver trees I am sitting on send you greetings—also the very cold very clear little green lake and the mountains with the long pure line of a snow ridge on its left side
<div align="right">GOK to AS, June 23, 1930</div>

What he would never read is the description of the New Mexico sky that she penned a few nights before he died. That letter, written on paper so thin that I can see my hand through the page, arrives too late. Both page and body frail, thinned, translucent. Her final gift to him, one he does not receive, is the same one she has been sending him for most of her life: the translation of the ineffable into a form he could hold in his hands. Whether in paint or in words, time and again, she offered him the stars, the sky, the incalculable moment when day becomes night.

Last evening after I mailed my letter to you. I sat down for a couple of hours and watched the day go and the night come— Lying on the roof—looking at the western sky line—a very bright star and a strange thin cloud.
<div align="right">GOK to AS, July 10, 1946</div>

I cry that afternoon in the Beinecke because I know O'Keeffe herself, like her final two letters, arrived too late in New York to talk with her husband again and that she never forgave herself for not being there. I cry because I have shared those thirty years with them, page by page, word by word, immersed in two lives unfolding. And I cry because I know that O'Keeffe wrote Stieglitz almost every day she was away from him, sometimes more than once, and that even though their relationship was fraught, complex, and difficult, his death opened a void in her life. Letters, like bodies, just end one

day. They stop. And that summer afternoon at the Beinecke, I hold that ending in my hand.

I don't like to stop writing you—it is like saying goodbye and it makes me cry

GOK to AS, August 20, 1926

I became a letter writer long before I kept a daily journal. In those days prior to cell phones and texting and even reasonable long-distance phone rates, I wrote letters to my boyfriend from thousands of miles away. I had fallen in love with him at the age of sixteen, after he took me reef walking under the full Hawaiian moon. We had poked our fingers at the lavender anemones and then upturned lava rocks in search of starfish and cowries. For two years, we did not go a day without talking.

The afternoon Christopher left the island to begin Plebe Summer at the Naval Academy, I drove home from the airport, went to my room, turned out the lights, and climbed into bed. At eighteen, I had no idea the heart could wither even when no weight pressed against my chest. Beneath my comforter, palm leaves rattling against my bedroom window, I thought I might suffocate from pain.

Within a month, I too left for college. I found myself at the University of Nebraska, two thousand miles away from my family in a state I had only visited. Corn, rather than the sea, lapped against the campus. My dorm room had been painted mustard yellow, and the walls devoured any light. I ate alone, walked to class alone, sat on the grass and watched the Nebraska natives stride with purpose across a campus they had practically learned to walk on. Every night I wrote letters to Christopher, sitting at the built-in desk in my dorm room. He sat there with me, in an 8 × 10 frame, parade dress, shiny gold buttons, soft hazel eyes that I can still recall almost thirty years later.

Pages and pages of letters, every night, their thickness bursting from the business envelopes I bought in bulk from Walgreens. I told him about my classes, my roommate, the food in the dining hall, the bewildering fraternity parties, the weather, and how the city of

Lincoln became a sea of red on game days. Or at least, that is what I imagine I wrote. Because I don't actually know. Those hundreds of pages, written daily over the first two years of college, are gone. I don't know if Christopher saved them at the time and tossed them later or if he never saved them at all. Plebes got very little space for personal belongings. Perhaps those pages were too much to store.

Here is what I do know about those letters: they documented a period in my life where I was changing and growing quickly, almost ferociously. And writing those letters helped me make sense of those changes. I looked forward to my evenings, when I could write under my desk lamp. With pen in hand, I felt more centered, more in control, even if I couldn't understand why everyone around me seemed to want only to binge drink. In many ways, I would give anything to have those letters back, to be able to see exactly how my eighteen-year-old self learned to be away from her family in a beef-fed state and eventually find a place of her own. But another part of me relishes the fact that the letters are gone, because in their absence I have the memory of the physical act of writing, the ways in which those letters returned me to myself. When I would sit down to write, hail spitting against my tenth-floor windows, my roommate out for the evening with a man eight years her senior, I recognized myself in my letters. I came home to her as soon as I began the salutation. Even as I changed, I remained the same. And with each sentence, and the understanding each sentence brought me, I welded my new world onto my old.

Too often, I think, we focus on the content of letters—what they tell us about a historical moment, a person's life, the cultural period in which they lived. We mine letters from the past, extracting names and dates like ore. But letters give us something more than information. They do indeed document, but they most especially document a self who is becoming—a self stitching together, word by word, a version of who she thinks she is. In that way, the writer of personal letters, especially letters to the same Dear across an extended period of time, writes as much to understand herself as to relate information to another.

I see this in O'Keeffe's letters clearly. Yes, they can tell us when she completed certain paintings or how often she walked to Palo

Duro Canyon—information that can be organized, placed in columns on a page. The more dynamic and interesting story her letters tell, though, is the story she pieces together of a girl from a farm in Wisconsin who becomes a central figure of modernism. And she never drops a stitch. We can never say for certain where the farm girl ends and the artist begins. Her letters detail the process of becoming in familiar and unself-conscious lines. She writes as much to find out how she thinks and feels about her world as to inform anyone of the events in her day.

> —*Just telling you of the events of the day doesn't seem to have any particular significance—it is something else that happens— and that something is difficult to define—*
>
> GOK to AS, July 18, 1928

Of course, the glimpse of O'Keeffe evolving that her letters afford us—the self she limns from one line to the next—cannot be affirmed as a more authentic or real self than the self revealed, say, in her Pelvis series or the self presented in her autobiography. We are tempted, by the intimacy of letters, to assume that a more real or true self is being disclosed, but this is a dangerous assumption. Any act of writing is an act of crafting—a manufacturing of an "I" on the page. The writer makes decisions—consciously and unconsciously— about what to leave in and what to take out; how to turn a sentence, describe an experience, distill a day into five hundred words. The "I" we meet in personal letters is, most certainly, an intimate "I," one of the most intimate expressions of the "I" we might hope to find, but it is not the only "I" or the most true "I." Like a painting in one of O'Keeffe's series—her Jack-in-the-Pulpit or Black Place series—her letters give us one more way to look at the world, one more way to understand. And we are grateful for the angle they provide.

> *Everyone has gone somewhere—and everyone wanted me to go along—I just wanted to stay at home and look at the ocean and be still—I wish you were here—This thing that the ocean is—that I like so much—terrifies me—the long steady roll of the clean green breakers—the blue day—the spray like the manes of wild*

horses flying back from the top of each wave—It is wonderful—
but it makes me want to put my hand out to you for
reassurance—maybe because I have gone farther into the
unknown with you than with anyone else—Going it alone
terrifies me—I at least want to feel your love with me—

GOK to AS, June 2, 1928

Ironically, my mother saved all the letters Christopher sent to me during those two years. First I saved them, stored them in a box in my desk, reread every single one many times, often with tears running down my face. The point of plebe year at the Naval Academy is not unlike the point of the military in general: to break the individual in order to build the corps. His letters described the breaking in the most visceral of terms. In Annapolis, he was as alone as I was. I could not understand what it meant to "chop" through Bancroft Hall, but I certainly recognized his despair.

When he broke up with me, the summer after our sophomore year, under another full moon on Oahu, I wanted to burn his letters, as well as every gift he had ever given me. My mother allowed me to throw the stuffed animals and sweaters in the trash, but she took the brown box of letters and put them in her closet. Eventually, she mailed them back to him.

She recognized the value of his letters—not only for me but for him. In the way we return to ourselves each time we put pen to page, letters belong as much to the writer as to the recipient. We tend to think of letters as vehicles for vaulting time and space, carrying the "I" to the "you," but letter writing also binds the "I" to the "I"—the "I" writing at the end of the day to the "I" who began it or to the "I" who wrote yesterday or the "I" who left the farm, the island, the family. Anyone who has ever written a letter understands the grace found by manufacturing and securing on the page, however fleetingly, her version the world—what she saw, how she felt, what she did.

Unlike diaries, though, where a writer might find some strength or solace or comfort in simply getting words on the page, letters go out into the world. The "I" goes to the "you." In that way, letter writing is risky writing. Years before I was born, when my newlywed parents were stationed in the Philippines, my mother received a

letter from her own mother. It arrived with the rest of the mail one afternoon, and my father opened it when he saw it on the table. In 1968, a letter finding its way from Rapid City, South Dakota, to Subic Bay was no small miracle, and I imagine it was the first piece of mail he opened that day. After greeting my mother, my grandmother confessed that her husband, my mother's father, had run away with the maid. He was living somewhere in Mexico; she had only debt and ruin. Because my father opened my mother's mail, he learned of this loss before she did. When my mother found out, her outrage was not directed at her own father, the one who wouldn't even have the decency to grant my grandmother a divorce, but at her husband, the one who had opened her mail.

As in most families, in mine letters were sacrosanct. You opened only a piece of mail addressed to you. To this day, I ask my own husband permission before opening his junk mail. Letters ferry the body more than they ferry information. From the faraway, letters arrive, bearing not the person but the next closest thing. After the salutation, we write "the body" of the letter. Our words physically stand in for our presence, and any hijacking of those words is a hijacking of that body. Which is one reason we like to read other people's letters. As Thomas Mallon points out in *Yours Ever: People and Their Letters*, there is "pleasure to be had in violating someone's privacy." This letter, we understand, was never meant for us.

> *Then came your letters—near noon—I was lying down—so dear—Dearest—so beautiful—so much more real—so much more very real than they used to be because I know what closeness to you means—Lips—arms—legs—body to body —warmness—wetness—lovingness—sleepiness— —forgetting*
>
> GOK to AS, August 8, 1918

O'Keeffe saved every letter she received from Stieglitz, as he did her letters, bequeathing us one of the most complete correspondences ever. And not just his letters. Letters from family. Letters from friends. Letters from business associates. Letters from fans. All of them. From the beginning, long, long before she was O'Keeffe; long, long before

7

her art could command the room as well as top dollar, she saved her letters. With no idea of the fame or fortune coming to her, she understood, in her almost curatorial dedication to them, the value of letters, the weight of those pages. Even at a time in history when it was commonplace to save letters and reread them again and again, O'Keeffe demonstrated unusual care and attention.

She also understood the intimacy of the self borne by personal letters. As she waded through Stieglitz's estate in the years immediately following his death, she sequestered his letters from public view, extending the restrictions on the most personal of his letters. After her own death in 1986, their letters were sealed for twenty years. When they saw the light of day in 2006, they arrived in a world that O'Keeffe could not have imagined. Sealed at the very moment when computers and the Internet were just becoming available, they reappeared in a world where letter writing has almost ceased to exist.

The other day, I went to the store to buy some stationary. I had dedicated myself to writing my mother-in-law a weekly letter because I knew how lonely she was. At eighty-five, she could not manage e-mail or a computer, but she still walked down for the mail every day. For the first two months, I wrote on whatever paper I could find around the house—mismatched notecards, printer paper, colored sheets found in my youngest son's room. But I soon yearned for pretty paper, rich and creamy and thick. Long before I had read Demetrius's injunction to letter writers in fourth-century Rome to consider their letters "a kind of gift," I wanted my letters to be beautiful.

In our small town, I could find no stationery at the store, not with the wrapping paper, not with the cards or the candles or the office supplies. When I finally found a clerk to help me, I had to actually explain what stationery was. She kept dragging me to the Hallmark cards.

When I tried the next store, I was directed to printer paper and sketch pads and blank notecards picturing big-eyed dogs. Finally I found a box of stationery while on vacation in Tacoma, Washington. Thick green pages with sweet birds perched at the corners. When I took the box to the counter, I could not believe that all this

lovely paper cost only ten dollars. "This is gold," I told the young woman at the checkout. She smiled the smile you give to crazy people and put my hard-won stationery in a bag.

At home, I began writing to my mother-in-law on my pretty green pages. I felt the smooth glide of my pen across the heavy paper, delighted in the curling of my letters. I noticed the way I turned my pen in my fingers every ten words or so, as if evening out the barrel. Each sentence I tried to render beautifully, my cursive full and round. I wrote with intention, envisioned her reading the letter with every word. For the space of that letter, I held my mother-in-law in my mind, in my heart, in the physical movement of hand across page. I read every line in her head. The body of my letter eventually held by her own. Unlike phone calls, not interrupted. Unlike the immediacy of conversation, reflective and inward. Unlike e-mail, physical and slow and not dictated by anything more than the size of the page. In the quiet of the morning, once a week, I began to relish my letter writing time—not only because of the joy I hoped my letters would bring but also for the reflective space that physical writing opened up in myself. I considered my audience: What would she like to know? I considered my week: What was worth describing? I considered myself: What did I continue to hold on to? Unlike my daily journal writing, which was also inward and reflective, letter writing opened a space bound to another person. We collaborated together in filling the page.

I have long loved language, so letter writing is, for certain, a more joyous task for me than for many. Still, I was surprised to learn that the average person in an average life sends eighteen thousand letters of one sort or another. Perhaps we write so often because letters are so democratic. You need only be literate and in possession of a stamp. In addition, we know the form well. We have been writing letters for well over two thousand years. The Greeks and Romans wrote the earliest letters, introducing a format that we still use today: salutation, body, and good-bye. Their letters look remarkably like our own. They chastise the recipients for not writing sooner. They seek money. They describe events. They reaffirm friendships and offer consolation in times of loss.

While the Greeks may have been the first letter writers (in the eight century BCE, Homer included a letter in a scene in the *Iliad*), the Romans were the quintessential letter writers. Simon Garfield explores the history of letter writing in his book *To the Letter*. He opens with a description of the ruins at Vindolanda, a series of Roman forts dating to the first century and located "across the narrow neck of Britain." In 1972 archaeologists unearthed a "treasure trove" of personal items at Vindolanda: leather sandals, earrings, tools, purses, hides, and, most surprisingly, letters. Two hundred fragments of writing, most on thin wooden writing tablets, slivers of birch and alder, no thicker than a millimeter, written to soldiers from their families. Within decades, a thousand letters would be found at the site. Ironically, these early letters had been thrown away by the soldiers, left in a pile of trash to burn. Like so many letters, the vast majority really, these letters were "not written with an eye toward posterity." They were ordinary and daily and intimate. Even at its very start, letter writing was, as Demetrius would later describe, both "elegant" and "plain," a gift indeed—a gift meant not for the future but for the present.

Letter writing would suffer a demise during the European Middle Ages, when few outside the church could read or write, but with a new increase in literacy, the establishment of the middle class, and the invention of the printing press, letter writing was reborn in the Renaissance. The golden age of letters began in 1700 and lasted until the First World War, with the nineteenth century blossoming into the epistolary age. Henry XIII created the first regular mail service in sixteenth-century England, used mostly by royalty. In the seventeenth century, the government began delivery service in England. In 1842 the postal service that we recognize today began in the United States.

While we have inherited the template of letters from those who wrote before us, we have also inherited a belief in the personal value of letters. Years ago, the recipient paid for the letter, not the sender. This meant that a writer penned her letter knowing that her lines needed to be worthy of the cost the recipient would bear. Care and attention were lavished on those pages. Early letter writers made use of all available page space, often writing diagonally across the page

and filling every margin. With the invention of the postage stamp in England in 1840, the recipient no longer had to foot the bill, but for the next hundred or so years, letter writers would often write with the same dedication to making their words worth their weight.

O'Keeffe was no professional writer. Neither she nor Stieglitz are to be found in books dedicated to letter writing and letter writers. Though they wrote thousands of pages, most of them beautiful and raw and real, neither she nor Stieglitz is considered among the "great corresponders" of the past. She is no Woolf, no Nin, no Heloise. More perhaps legendary is her very mistrust of language and dislike of words. Time and again she bemoaned the limitations of words, valuing the flexible nature of paint. Paint was her vocabulary, she would say.

Yet she wrote. And she didn't write occasionally. She wrote daily, often long letters and to multiple people in a day: her husband, her sisters, fellow artists, friends. Even when a phone call would have been convenient, say from Lake George to Stieglitz, who had remained in the city, she chose the pen. Regardless of what she might have insisted, writing was clearly not a torture for her. One look at her letters to Stieglitz, and the first thing you notice is their beauty on the page—those wild lines coursing like so many waves against the shores of her margins. The second thing you notice is the absence of mistakes—no erasing, no crossing out, very little emendation at all. They arrived fully and wholly alive in the world. Her spelling might have been atrocious, but she didn't cross out a difficult word in an attempt to get the right spelling. She just moved on.

Two beautiful letters from you, Dearest One. Letters like the day.
AS to GOK, June 23, 1930

Many people, I imagine, might argue that O'Keeffe's letters do not rise to art. Just because you own a paintbrush doesn't mean you possess talent. Two thousand letters sent over thirty years might amount to just a lot of paper. In the early eighteenth century, Samuel Johnson insisted that the term *literary* could not be

applied to missive letters at all. He felt they were written in a familiar, even low, style. As "natural letters," not meant for the public or posterity, they had no real audience, sought no public. The letters we tend to value and save—at least collectively—are those that bring important tidings or describe important events: Dr. King's "Letter from a Birmingham Jail" or Abraham Lincoln's letters from the heart of the Civil War. Even those who anthologize letters tend to gravitate toward letters from the famous. In their introduction to *The Oxford Book of Letters*, Frank and Anita Kermode suggest that "good writers write good letters." Unlike those who stand bereft of literary talent, they have "the resources to deal with suffering and death."

Yet O'Keeffe's letters *are* beautiful. They are beautiful in their rivers of blue ink, in how they fill space, and they are beautiful in how they translate the "I" for the "you."

Tonight I'd like to paint the world with a broom.

GOK to AS, November 4, 1916

My center does not come from my mind—it feels in me like a plot of warm moist well tilled earth with the sun shining hot on it— nothing with a spark of possibility of growth seems seeded in it at the moment—

It seems I would rather feel starkly empty than let anything be planted that cannot be tended to the full possibility of its growth.

GOK to Jean Toomer, January 10, 1934

There is so much color in the cliffs one doesn't think to look for the sunset.

GOK to AS, August 27, 1934

But all this is something that stretches very far—far into me— touches things in me way beyond what I knew I was before—It is as tho I thought I was one thing and find I am something else— something way beyond myself—

GOK to AS, August 1, 1929

They are also compelling in less specifically literary ways: how they enact the tenets of modernism, how they document a passionate and fraught relationship between two of the greatest artists of the twentieth century, how the teach us to look at what might pass unnoticed, how they place us on the plains, the shore, the ever-widening desert.

Perhaps most compelling of all is what O'Keeffe's letters don't give us. So much goes unsaid. Because letters are intimate documents, of course much remains unwritten, understood. The writer and the recipient share a long and rich history. Neither needs to provide context, introduce characters, or summarize. That is to be expected. But here I am talking about a deeper unsaid—the things that remain unsaid because they simply can't be. O'Keeffe's dash often signals our approach to the ineffable, as do the canyons of white space. Sometimes O'Keeffe herself will name her inability to translate her experience fully on the page. She will use her words to frame the emptiness.

It is those gaps and voids that draw me most strongly to O'Keeffe's letters. Like her visual art, they challenge my reading, my response, the very way I see. It is when O'Keeffe gives me the least that I learn the most about both writing and my expectations. Her blank spaces invite me, as the reader, to fill them. In that way, her frustrations with the limits of language become the most beautiful aspect of her literary art.

Early in O'Keeffe's career, she read and repeatedly reread Wassily Kandinsky's *Concerning the Spiritual in Art*. Of art, he writes, "That is beautiful which is produced by the internal necessity, which springs from the soul." Rather than record the plain facts of what they saw, Kandinsky encouraged artists to give shape and voice to their emotional centers. Like many of the modernists, O'Keeffe spent her life trying to paint the emotional truth—not the hills above Ghost Ranch but how it felt to look at the hills; not the center of a peony but what she saw in that peony. Many viewers had trouble grasping a beauty that was independent of meaning. They wanted the flowers explained, the lines narrated, the shapes to look more familiar. They wanted a story. But O'Keeffe never compromised on

her vision. Art, she insisted time and again, was filling a space in a beautiful way.

I have approached O'Keeffe's literary art in the same way she asks us to approach her visual art, not with a story, a narrative, a fixed understanding, but with Kandinsky's imperative in mind: finding the emotional truth in a subject and translating it for another. Had O'Keeffe written methodically about her months in West Texas or at Ghost Ranch, perhaps I could have produced a scholarly book about O'Keeffe's correspondence. But she didn't. And I haven't. She writes with passion and energy and an honesty that feels as bare as the desert itself.

The bulk of the letters in the Stieglitz/O'Keeffe Archive, at least in terms of O'Keeffe, are the letters she wrote to him. The essays that follow rely most heavily on their correspondence to each other, though I am not telling the story of their lives together.

Nor is this a biography. I trace O'Keeffe's life fairly chronologically, but I do not seek a linear narrative about O'Keeffe's letters, her art, or her life. Sometimes her letters are at the very center of an essay; sometimes O'Keeffe doesn't appear at all.

This is also not a memoir. I bring myself into some of the essays, while I am seemingly absent in others. When I do write about my experiences, it is not to compare my life to O'Keeffe's or to suggest that my story is somehow important to understanding hers. Rather I reveal the braided path we travel when trying to truly understand a subject. Knowledge that passes through the heart is never linear. Visually, I like to think of O'Keeffe's painting *Gerald's Tree*. On first glance, it is a tree growing from the desert floor. Look harder, and we see that she has reproduced multiple angles from which the sun might be coming. In terms of reality, the shadows make no sense. In her understanding of the subject, they are the only possible way to cast the light.

As I write in the preface, this book attempts to convey, through writing, the kinds of truths O'Keeffe sought in her visual art. As O'Keeffe pushed paint on the canvas, I try to push words on the page. These essays rely on voids and the abstraction of experience: the speculative, and time leaps, and juxtaposition. They ask readers to question what they know about letters, about art, about

landscapes, about memory, and about essays themselves. They set a flower in the eye socket of a cow's skull and then gaze through a fishhook, a pelvis bone, the past. They approach O'Keeffe's letters from as many angles as possible—the same hills again and again and again—in pursuit of the ineffable: those memories, moments, experiences, and events that are stored within our bodies and beg to be named, painted, held.

Years ago, O'Keeffe's letters took up residence inside my body and refused to leave. They shaped how I saw the world. They challenged my understanding of narrative. They made me question the limits of writing and ultimately of art. They reminded me of the intimacy created in putting pen to page, as well as the solace found in fashioning a sense of self on sheet after sheet of paper. For so long, I thought the letters were what I was writing about. Given how loudly they clamored inside me, I wanted others to see their beauty and wonder. But such a response would be akin to feeling satisfied with O'Keeffe's use of the color blue. It misses the real magic. To really appreciate O'Keeffe's literary and visual art, you must move out from what is actually on the page or the canvas and risk the journey across the empty space. Actually, what you must risk is your self, your very way of seeing and being. That is what she asks of us time and again. She asks it of herself and she asks it of her audience. It is this challenge that *Letters Like the Day* tries to meet—to risk my way of seeing in order to open a space where you might risk yours.

I had such a sinking feeling in my stomach—or somewhere in me—a feeling that I had mailed you a letter—and that really— what I feel—what reaches out to you—no matter where I am— really wasn't in the letter at all—and that is really all I am wanting really to send you—

GOK to AS, July 29, 1928

Holes in the Sky

I HAVE BEEN SITTING in my study with Georgia O'Keeffe for the past few weeks. She knocked on my door one morning in early May—perhaps having heard that I had been reading her letters—and handed me a wide-brimmed hat before entering the house. We've spent most of the last days sitting across from one another, she in an old armchair upholstered in mauve, I in a straight-backed chair with popped springs. As is her nature, she is quiet most of the time, preferring silence to talk. Words only get in the way. On the first day we sat together, the tulips in my front yard an army of color, she said, "Words have been misused."

In my confusion, I asked her if she meant a particular word, something I had said or not said.

She shook her head and continued, "The usual words don't express my meaning, and I can't make up new ones for it."

I nodded, knowing all too well how language fails us. Paint, of course, is her syntax; pigment, her letters. "I paint," she once said, "because color is a significant language to me." In that medium, I am illiterate.

O'Keeffe prefers herbal tea, as do I, and we both like to sit in the morning silence, my young sons off at school, the house settling around us. Steam from the cups clings to our cheeks and chins. The heater glows at our feet, cutting a path of warmth along the floor of

my basement study. As if around a campfire, we turn our legs, brown our calves. During the past three weeks, sitting under my one window, we have said little. In her worn face, crumpled like a sack, felted with use, I see my husband's aunt Eileen, who at ninety-six is two years younger than O'Keeffe but who is dying in a bed in Richmond, Virginia, thousands of miles from here. "We are all dying," I said to Michael when we first learned that Eileen was no longer eating. "Yes," he said, "but Eileen is dying faster."

Our cat, Luna, pushes open the door to my study, her white paws bright against the dark carpet. "That's fine, fine," O'Keeffe says and pats the space next to her. Eileen uses the same phrase.

"That's fine," O'Keeffe repeats as Luna comes closer to her out-stretched hand. At ninety-eight, sight failing, bones thinned to translucence, everything seems to be fine.

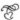

Before my first son, Aidan, was born, I drew a picture of the two of us running in the winter dark while the rest of the world slept. We appeared very small as we ran along the floor of Cache Valley, in northern Utah, the Bear Mountains rising in black like a quilt set to cover the earth for winter. In the picture, my legs churned under me, bent at the knees, caught in that moment when neither foot has contact with the ground. I was flying, and my hair trailed out like a scarf.

I drew Aidan running as well, inside of me. He assumed the same pose in my belly, bent knees, churning legs, only he was swimming rather than flying, making his way through water as warm as the South Pacific, in darkness that even stars failed to pierce. While I listened for the approach of a car or the bark of a dog let loose on its morning business, I imagined that he ran to the shush of waves, an ebb and flow of water that matched the rhythm of my stride.

I ask O'Keeffe about Eileen. "How long, do you think, before she dies?" A silly question. O'Keeffe has never met Eileen, only knows of her as the old woman whose body is failing, whose downward slide has Michael and me huddled during parts of the day, trying to decide if and when he should fly back. O'Keeffe looks out the one window in my study, a basement window that frames the cherry tree in our backyard and, beyond that, the sky.

From our position, underground, we are afforded the same perspective as in her painting *The Lawrence Tree*, where the viewer looks up from beneath the tree into branches and stars. A tree standing on its head is how O'Keeffe described it to her friends. What I love about that work—as with so many of her paintings—is that our own place in space, as viewers, is uncertain. Are we on our backs on the ground? On a bench? In our graves? Or are we floating in space like one of her skulls, hovering in a kind of ecstasy?

The Lawrence tree exists. You can go to northern New Mexico, to Lawrence Ranch, and sit underneath it. It is site specific like many of her landscapes. But when you look up into the tree, you won't see what O'Keeffe saw. Your tree won't be nearly as wondrous. That's because O'Keeffe faithfully rendered aspects of the actual landscape—the contours, the planes—and then abstracted them to get at the emotional truth of her vision. In *The Lawrence Tree* we have a record of what it meant for her to look up into those branches, the bliss she felt in its limbs.

I ponder the green leaves of the cherry tree outside the window of my study. Because O'Keeffe has not told me how to hold the death of Eileen in my hands, I ask her about the tree.

"What do you see?"

She sits in a chair beside me, Luna curled up in her lap. The house remains quiet except for the click of the space heater. O'Keeffe pets Luna, the long slender fingers made famous by Stieglitz running the length of the cat's body. I want to be the cat, to be petted by the hands that turned a tree on its head.

"Telephone wires."

Michael brings scrambled eggs and butter-soaked toast covered with raspberry jelly, which streaks the plate like blood. My finger follows the sticky river, red to my lips and the taste of childhood. Minutes later he arrives with juice, careful not to spill, and sets the glass on the nightstand. The bedroom remains dark in midday, as if someone in the house suffers a migraine or the stomach flu. The yellow eggs warm me from the inside out.

I was born in Texas, but it took O'Keeffe two decades before she made her way from her birthplace in Sun Prairie, Wisconsin, to the Lone Star State. When she did, it would feel like coming home. The boundless sky, the open plains.

She wrote to Stieglitz in 1916, two years before they became lovers, "The plains—the wonderful great big sky—makes me want to breathe so deep that I'll break—There is so much of it—I want to get outside of it all—I would if I could—even if it killed me—"

The open space of the plains would influence O'Keeffe throughout her career. You only have to look at her work to know that O'Keeffe was fascinated with holes, spaces. Empty places that pulse with energy. I am thinking of her pelvis bones, her flowers, her canyons. I read once that O'Keeffe had a "passion for voids" and that her frames—whether fishhooks, cattle bones, or geologic formations—are reminiscent of open windows in nineteenth-century paintings, windows that created feelings of longing, provided thresholds into the unknown. The window frames the abyss, contains it long enough for us to see it, experience it. Like a sculpture, the window simultaneously shapes the emptiness and births it.

The holes in O'Keeffe's work, her voids, were the subject. Not the bone but what can be seen through it. And what she saw was both beautiful and sad, terrifying and sublime, a space so complex, and charged, and personal, that words would never capture it.

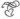

Aidan plays in the other room, chattering a combination of vowels sopped in drool. Six months gone from my body, he still topples like a tree when placed on the floor without support. He waved to me from the car seat where Michael had hurriedly strapped him down, apparently unshaken by his mother's place in the snowbank. Ambulance lights flashed red across his face.

In her autobiography O'Keeffe writes, "It is surprising to me to see how many people separate the objective from the abstract. Objective painting is not good painting unless it is good in the abstract sense. A hill or tree cannot make a good painting just because it is a hill or a tree. It is lines and colors put together so that they say something. For me, this is the very basis of painting. The abstraction is often the most definite form for the intangible thing in myself that I can only clarify in paint." I see this in O'Keeffe's work. Maybe because I have traveled to the places that O'Keeffe has painted and know the way she takes what is there and bends it. Consumes it. Digests it. Reinterprets it. I'm not sure of the right metaphor. The result, though, like her landscapes, contains no middle space. It has elements of the real and elements of the abstract—both the near and the faraway—and never sacrifices one for the other. She would see no need for choice.

"Is it too late?" I ask, close to an hour after neither of us has spoken. I don't know if I am asking about Eileen or about my own cloudy ways of seeing.

When I look to O'Keeffe for an answer, I see she has fallen asleep. Her hand rests on Luna, midstroke.

Last night Michael's mother, Kay, called us close to midnight. She and Eileen live together in an apartment not far from Michael's sister, Nancy, and her family.

"Eileen is dead," Kay cried. I could hear her easily, even though Michael held the phone to his ear. Her grief could not be contained by a mouthpiece.

"How do you know?" Michael asked, voice soft.

Kay had gone into Eileen's room to check on her, just as she did every night before bed. She had tried to rouse Eileen but couldn't, and she was convinced that she had died.

"I have lost my second mother," Kay cried. I could imagine Kay on the couch in her living room, surrounded by the antiques she and her late husband had collected over the years, strong, solid desks and end tables, all polished until they shone like stars. I knew how her shoulders would shake quietly as she held the phone, the tiny gasps that would escape her lips. Not large sobs but rather constrained sadness, gathered and collected in the same way she had led her life.

When Michael's father died, we stood in the hospital room, Walter still in his bed, his mouth frozen in a final gasp. Michael and I had come the day before, having flown over the roads between Indiana and North Carolina, not even taking time to pack. When we arrived, his father breathed in long gasps, sometimes going for minutes before taking in more air. Then, in the early morning, just as the sun was breaching the Appalachians, one of the pauses became permanent. In the wan light, Kay, Michael, Nancy, and I circled the bed, gathered around a center that was gone. It was there I first heard the controlled shattering of Kay's heart. The tiny breaths, pants almost, of grief.

"Call Nancy," Michael said to his mother, the phone held tightly to his ear. He looked at me with eyebrows raised, clearly unsure of what to do. "Ask her to come over."

Ten minutes later Nancy called us back. Eileen was only in a deep sleep. She was not dead, though Kay had tasted what it would feel like when she was alone.

It was January 6. Eight inches of snow had fallen by daylight. Large, wet flakes still swam through the sky, like a flock of fish caught in a

current running parallel to the ground. When I left the house that morning, I was the first to mark the snow.

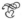

We are standing at the mouth of Green Canyon, about a mile from my house. O'Keeffe hadn't wanted to leave my study, but I convinced her that days like today—May afternoons where the sky is charged with blue and snow still caps the mountains surrounding this northern Utah valley—cannot pass unwitnessed. Of course, it takes little to encourage O'Keeffe to come outdoors. She loves the natural world, draws her inspiration from it. So often in her life, she fled the city for the shores or the plains or the desert. She once declared that her very center did not arise from her mind but rather resembled "a plot of warm moist well tilled earth." No, her hesitation this afternoon is not from her desire to be inside rather than out but from her need for solitude. Translating the unknown into the known, framing the void, requires isolation. She wrote to Jean Toomer in 1934, "I feel more or less like a reed blown about by the winds of my habit—my affections— the things that I am—moving it seems—more and more toward aloneness—not because I wish it so but because there seems to be no other way." She doesn't like to be around people, especially strangers, and, when electricity and indoor plumbing arrived in O'Keeffe country, bringing more and more neighbors, O'Keeffe almost left. At the mouth of Green Canyon, new housing projects grow like canker sores. I notice that we both keep our eyes trained on the canyon walls, the sky, the faraway places still free of "man's destruction."

We stand, in the middle of the day, in the middle of the week, in the middle of a canyon birthed millions of years ago by a river that now runs only in spring. Juniper dots the valley walls, big tooth maple. It isn't northern New Mexico, but it's not too different. Above us, the sky.

"And what do you see here?" I ask, pointing to the scraped hills, the bonsai-ed juniper. "What would you paint?"

Last summer, when I sat with Eileen in her room, sun pouring through the window, the woods alive with birdsong, I knitted a scarf. Every now and then, while perched on the edge of her bed, ball of yarn unspooling in my lap, I reached for Eileen's hand and rubbed the thin skin, conscious of how often we restrict touch to only the infant and the infirm. With each passing hour, I purled the invisible flakes of her skin as well as the dust motes floating in the sun into a scarf I was knitting for my mother.

The snow crunches beneath my running shoes, January light thin and brittle. My breath is slow and quiet from years of running, and my hair beats an even rhythm against my jacket. Five miles into my run, my mind is empty of thought, though my feet register the softness of the deep snow. I am running on cloud.

And then I fall.

Marjane Satrapi's graphic memoir *Persepolis* tells the coming-of-age story of the author, a child growing up in postrevolutionary Iran. Late in the book, we come to a cell, the square frame in a comic, that is totally black. The cell recounts the moment when Satrapi returns to her street after a bombing and finds that her best friend has been buried under the rubble of her house. Only a bracelet remains. Satrapi's howl is rendered in blackness. Such emptiness is much more horrifying than any image Satrapi might have drawn, any words she might have conjured. We import our own demons into that black cell. We fill her void with our pain.

O'Keeffe was smart not to trust language. "Words and I—are not good friends," she wrote Stieglitz, just at the moment in her career when she first broke through in her painting. For two years she had been struggling in South Carolina to give birth to her own vision. When she moved to Canyon, Texas, the landscapes, the boundless sky, gave her the space to realize it. Her friend Anita Pollitzer took the charcoals she had been making to the famous Alfred Stieglitz to see what he might say. His response, though potentially more legend than fact: "At last a woman on paper." What he held were her early abstractions, sketches without narrative or figure. Two blue lines— one fairly vertical and another lightning shaped. A swirling ball of black. O'Keeffe had been reading and rereading Kandinsky's *Concerning the Spiritual in Art*. Her work realized Kandinsky's commitment to emotional truth, the "departure of art from the objective world and the discovery of a new subject matter based only on the artist's inner need." Years later, long after she held her first pelvis bone to sky, she would quip, "Nothing is less real than realism."

O'Keeffe never lets others watch her paint, throws white sheets over her work when visitors arrive, so I guess I should not be surprised that she won't tell me now what she sees in the canyon walls around us. In fact, she isn't even looking up. She is looking down, at the rocks near her feet. She pulls a tiny white shell from the ground; it is round and swirling. I thought her skin white until she holds the shell. Now I see how many whites exist in the world.

"It's the shell of a mountain snail," I tell her. "But I like to pretend it's a seashell left over from when Lake Bonneville, a giant inland sea, covered this area. Thousands of years ago. We walk now on the shore left by the lake, the bench."

"Texas was like an ocean," she says. "Nothing but sky and prairie. More like the ocean than anything I have known." She turns the small shell in her fingers, bits of dirt sifting down.

"I grew up in Hawaii," I tell her. I know she has been to the islands three times. I have seen the twenty paintings she completed after her trip in 1939. I feel closest to Hawaii when I am in Utah, which makes people laugh, but it's true. Maybe it has to do with how you can see an entire train surge up the valley, the oceanic space. But sometimes I wonder if it's about the landscape itself, how beautiful it is. I pick up my own shell. "Such beauty demands conversation," I say, knowing, of course, that no noun embodies the emptiness in a shell.

"Do you know what art is to me?" she asks, her shell now in a pocket that she pats softly with her hand. "Filling a space in a beautiful way."

Here is a flower, she says, a black peony, and we see the artist herself.

I am shaking when I call my parents, the momentary warmth the eggs provided now gone, the cold having rerooted in my core. "I'm okay," I begin, and there is silence on the other end. "I was hit by a van this morning while running," I say, "but I'm fine. Michael made eggs. I'm fine."

O'Keeffe is walking back from the trailhead toward the parking lot, the canyon now behind us. Cache Valley spreads below us, rows of houses, trees, cars. I check my pockets as we walk, convinced I have left something behind. I realize, though, I took nothing with me.

We walk on the shore of a many-years-lost lake, between clavicles of the earth. The mouth of the canyon is behind us, and a red-tailed hawk circles overhead. Against the sun, he is but a shadow, errant

comma in search of its sentence. Were I to paint the valley, I would paint the canvas blue, the blue of the Pacific Ocean, the blue of ancient Lake Bonneville, not a slope or rock in sight, the earth under water so that everything is sky.

When I turn, turn, turn—here, first, the moment before the turn, when all that aches is my head and my pride, sprawled in the middle of the road, snow seeping into my running tights, ice caught in the bands of both gloves—and then the actual moment I turn, just my head, to look behind, in the direction I have come, because something tugs at my heart to do so, or at my gut, or maybe it's a voice I hear, quiet but insistent, that tells me I do not have the road to myself, or maybe, yes, maybe it's the vibrations of the vehicle on snow-covered asphalt that I feel, hand to rail to check for trains, hand to doorknob to feel for flame, rattle climbing shin, then spine, then inner ear, so that I turn and see how thin the line is between here and there, safe and not, whole and broken.

A van the color of snow bears down on me, already so close I cannot see above the headlights—they are on, white and open in fright—and the tires, spinning black, the world reduced to grille and rubber and the sound of the future swerving out of control down the hill, sliding this way and that, weaving back and forth, tread throwing snow like fire, breath, the smell of rubber.

Like the animal that I am, I claw, four paws, toward the edge of the road, knowing I will not make it, thinking only that I must try and live for my son. I offer the van my flank in hopes of sparing my head, which means I am no longer facing the monster but trained on the pile of plowed snow that rises steeply like a canyon wall lit with morning sun. Aidan, then, is whom I am thinking of when the van reaches me. He fills my body once again. Here, then, the van is hitting me. Scream of engine, flash of light, my son who cannot sit on his own without toppling like a tree, ice shards in my mittens, tire in my side, air aflame and filled with snow so that all is bright and burning. I am lifted into the air.

O'Keeffe and I are snorkeling to the Haleiwa Trench. In a letter to William Howard Schubart in 1950, she wrote, "I want to go to Hawaii again"; so we have gone. It wasn't hard to convince her. She sees the ocean in almost every open space, as do I. The Bear Mountains, where I live, is a reef without its sea. We could feel the salt water of Lake Bonneville lapping at our feet.

The mask and snorkel I keep in the garage fit her. We both wear child-size masks, our faces thin and narrow. Even so, her mask is filled with water, the wrinkles like ravines channeling water beneath the rubber edge. I show her how to clear it.

"Press the top of your mask and blow out," I say. We tread water, black fins windmilling our feet, and I demonstrate. "Do it in the water," I tell her. And we both sink back into the sea.

The Haleiwa Trench is on the north shore of Oahu, just past Haleiwa Town itself. In the winter, surf tournaments are held offshore, but now, in the late spring, the water is warm and calm. We are about twenty yards from the beach, both of us swimming easily. I listen to her breaths through her snorkel, checking to make sure she isn't panicked. Too often, beginning snorkelers scrunch their faces in fear and take deep drags of air. But O'Keeffe floats along the surface beside me, occasionally pointing at a colorful fish or a dancing patch of seaweed. I don't have to look at her to know she is smiling. I have read too many of her letters.

The sun casts forests of light all around us as we head for the trench. Lying fifty yards from the beach, it runs for miles parallel to the shore. The seafloor is now only about ten or fifteen feet below us, but I can feel the temperature change on my belly. Goose bumps appear on my arms.

We swim between two worlds. Below me, fish dart here and there, giant fleets of bright yellow-and-blue tangs, silver tuna and grouper, tiny purple wrasses. The ocean clicks and chatters, simmers. Seaweed moves with the current. On my back, I can feel the sun and the wind of the other world, the one I inhabit, the one with

air. My snorkel keeps me connected to that place. I hear the wind sing across the top of the tube.

If I wanted to, I could dive to the sandy floor below us, touch a head of coral or point to a particular fish. My ears would hurt with the change of pressure, and I wouldn't stay long before zipping back up to the surface, but I could, if necessary, still "touch." There is a kind of comfort in that knowledge, knowing that the "earth" is still within reach. But the deeper you travel into the ocean, the more you must give yourself over to the second world, the one filled with fish in neon colors, the one where the idea of ground no longer applies.

When the plankton arrive, we swim through rafts of cloud. I smile at the idea of water turned to sky, our bodies now birds, and watch the plankton filter through my water-wrinkled fingers.

Suddenly the trench appears, as it always does, a canyon in the sea. My heart starts to race. I can hear my breathing increase in the hollow of my snorkel, a physical response to enormity. At one point we had been in twenty feet of water. Then, just like that, the earth falls away into blackness. The plankton turn to stars in the face of nothingness. We cannot see anything below us, in front of us, or, with a few more strokes, behind us. We are floating deep in space. Save for the rattling breath in my snorkel, sound has ceased. My eyes try to sort through the layers of black, distinguish between the black above and below. We are without degrees, an emptiness that is complete. When I look over to O'Keeffe, to the tiny oval of glass in front of her face, I see her eyes. They are the brightest things around.

Here, then, is the void. Salt water enters the pores of my skin, tanging my lips. When O'Keeffe's arm briefly touches mine, the charge ignites my skin. What is outside, now in, returned to the saltiness of the womb. Black of crow. Black of night. We swim inside an O'Keeffe.

The part of me that defines who I am burrows under its wing.

And then I see the flash of O'Keeffe's arm as she swims past me, the palest of whites amid the black. The wake of her fins vibrates against my chest; tiny air bubbles cling to my bare skin and then

pop. Her passage a comet tail of froth. At the artist's movement, the emptiness is shaped, if only in the tunnel of her departure.

At the moment Eileen dies, Michael and I will be snorkeling on the Waianae coast of Oahu. We will be holding hands and following a green sea turtle whose shell is calligraphed with age. The turtle will drift in the current, poking the reef here and there, paddling his flippers. Sometimes he will change direction abruptly and swim right toward us, and we will have to use our fins to backpedal, the water turning to froth and lace. We won't know that Eileen has died, so our pace will be slow, happy to follow a turtle as he wanders along a reef of brilliant blues and yellows and greens. The sky will stretch above us, the sea below, and someday I will try and translate the moment, this "inexplicable thing," into words, attempting, like O'Keeffe, "to understand maybe by trying to put it into form."

A Walk into the Night

I

SHE BEGINS IT. In August of 1914. Twenty-seven years old, she is to most an old maid and has only recently returned to South Carolina to teach. Flowers, bones, and skies you enter like a room are years away.

The first letter must travel the hundreds of miles to New York, to 291. She is asking to subscribe to his publication *Camera Work*. The letter receives no written response, though her subscription must start. The second letter though, the one sent in January of 1915, after he has seen her work for the first time—"finally a woman on paper"—is where it really begins. She asks him to describe what her charcoals said to him. She wonders if she "got over to anyone" what she wanted to say. (His is the opinion she values most, though she admits this only in letters to other people.)

Her sentences are isolated by the long, ribbonlike dashes that will punctuate their correspondence. Voids on the page, ravines of ink into which everything and nothing must fit. Not unlike her drawings.

His first words back to her: "What am I to say?" This from the man who would hold court for hours at 291, his gallery and the

cradle of American modernism. This from the man who would roam and rage from one topic to the next—art, politics, religion, the nature of reality—yielding the floor to none.

Joy is what he tells her eventually, as he continues his letter. Joy is what she has given him. Her abstractions have brought him closer to her. "Much closer."

They have met only twice, briefly.

He is fifty. Married. He stands at the center of the emerging modern art movement. She is not yet thirty, virtually untrained, from a farm in Wisconsin. What she could see from her window, she owned.

She writes back on February 1 to tell him of her astonishment at being understood. "It's such a surprise to me that you really saw them." She was only trying to express herself. Something she can do in painting, though not in letters. "Words and I are not good friends."

Still, she wants to *talk* with him and won't be "completely outdone by a little thing like distance." Her letters will make the journey to him, even if she can't. There are few in her life who understand her choices, let alone her art. She will write to him at one point that "no one ever wanted me to do any of the things I wanted to do—and did—from the shoes I wore to the way I combed my hair—my friends and opinions—was all wrong—" But he has seen her.

At the 1913 Armory Show in New York, Duchamp's *Nude Descending a Staircase* introduces Americans to modernism. Showgoers are scandalized. They have no reference for what they see, no way of articulating the planes and lines before them, no way to bring the forms into a narrative they can hold on to. Only a few understand that modernism drives for the belly of the viewer, the gut, the formless, nameless, pulsing center of a being. Such a connection, by definition, is wordless.

He has no words either. "Perhaps because I am dead myself," he adds. "And words, just words, are so terrible. Rather by far a living aching silence." He tears up one letter to her, tries again.

<center>II</center>

In September of 1916 she moves to Canyon, Texas, to take a job as head of the Art Department at the West Texas State Normal College. Canyon, Texas, population fifteen hundred, sits on the edge of the Llano Estacado, the Staked Plain, one of the largest mesas, or table-lands, in North America. The ground slopes so gradually in the Llano Estacado that the incline is undetectable to the human eye.

It is absolutely flat.

The plains of West Texas are the remains of an ancient sea.

She writes in her first letter to him, on September 3, 1916, "The plains—the wonderful great big sky—makes me want to breathe so deep that I'll break—There is so much of it—I want to get outside of it all—I would if I could—even if it killed me—"

Like him, the plains get her. Mostly in their emptiness, their big-ness. The winds blow, the sun scorches, the glare blinds, but she loves it all. Nothing, nothing, nothing. She cannot get enough of the nothingness, "the holiness of it."

It is blank, like a canvass, like a piece of stationery, like a word unsaid.

Her teacher Arthur Dow wrote, "It is not the province of a land-scape painter to represent topography, but to express an emotion, and this he must do by art."

The first room she rents she despises. Wallpaper crowded with roses. This for the woman who will spend days mixing the exact shade of white for the walls of his gallery. She moves, then moves again, finally residing on the top floor of a clapboard bungalow four blocks from the college. Even though the house is in the center of town, she will never feel part of Canyon itself. The plains are what make her feel she has come home.

"You are more the size of the plains than most folk," she writes him.

<center>33</center>

She imagines coming to New York to see him but realizes she never would. "The letters have been so fine—I would hate to spoil it—so they couldn't be anymore." Letters that come almost daily, some of them forty pages in length. Letters that he prefers to write only when sitting outside—"to write indoors to you seem[s] absurd. Impossible." Letters that she composes while still in bed. Letters they carry in their pockets for days before sending. Thousands of pages over a lifetime.

And then the letter on September 26, 1916. She begins with the dark. "Isn't dark curious—sometimes it is still with you—sometimes you are just alone—and it's way off—sometimes it chases you—it is such an enormous—intangible—awful thing when it chases you on the plains—"

She is not only writing about the dark. She is writing about him, about them, about the headaches that render her paralyzed and keep her in bed with the shades drawn.

She lies, she says. To him. To herself.

She wants "to touch someone I like—then maybe I could be still."

He is "understanding."

And yet.

She writes, "Please don't—for a while—write me those letters that always knock me down—Sometimes—your letters are so much yourself." Some mornings she dreads their arrival. "You understand," she continues, "I am always glad—and you know how much I like them—It's that it's too much—I've got to get quiet—some way."

To her friend Anita Pollitzer she confesses that his letters are "like too much light—you shut your eyes and put one hand over them—then feel round with the other for something to steady yourself by."

He has written of Lake George, the lake in upstate New York where his family has a home, and the "turmoil" of the trees. He has told her, "It's a great privilege to be given the opportunity to look into a soul like yours—I feel it roaming through space and at night—"

More importantly, he has seen her drawings and paintings. She has sent him several rolls to do with as he pleases. ("They are as much yours as mine.") He will only be able to "glance" at them, as though he risks blindness in looking. One glance, he assures her, permits him to see more than others would see in months of looking. Once glance reveals "all the powers of the night."

Stop, she tells him. She is scorched by his gaze, like the scrubbed plains around her.

IV

Palo Duro Canyon lies twelve miles east of Canyon, Texas. The canyon is one hundred miles long, twenty miles wide, and eight hundred feet deep. It is the second-largest canyon in North America, the Grand Canyon of Texas. Formed by the Prairie Dog Town Fork of the Red River, which winds for miles along the virtually flat Llano Estacado only to fall dramatically off the Caprock Escarpment, the canyon is known for its fantastical hoodoos and colorful walls. Layers of rock rise from the red canyon floor in yellows, lavenders, and flame. She would say of the canyon: "It is a burning, seething cauldron, filled with dramatic light and color."

Some days she walks the distance from the town to the canyon through the oceans of sage, tumbleweeds, and scrub. The flat, the flat, the flat and then "a slit in the ground."

"I haven't any words for it."

She walks to the rim and eats dinner alone, watches the cattle move through the canyon, the clouds of dust at their feet. "Way off on the edge of the earth against the sunset were a lot of cattle in a string—[I] could see daylight under them—Like a dark embroidery edge—very fine—on the edge of the earth—"

She scales the sides.

"Merciless," she names it.

Not unlike the townspeople. Who cannot understand her dress, her talk, the way she wears her hair. There were problems from the start: "I feel it's a pity to disfigure such wonderful country with

people of any kind." Then later, "I feel like such a misfit." Within months she is "in a pen." She is an unmarried abstractionist living in rural West Texas. She is a pacifist. She entertains men in her apartment. She reads books written by Germans. She rides into the desert with married men and flirts with her students. Her paintings look like nothing anyone can name.

The next time she goes to the canyon, she wears high heels to keep herself from climbing. Shackled.

He both liberates and binds her. With him, she can be truly honest, yet such honesty creates its own cuffs. "I'm getting to like you so tremendously it sometimes scares me . . . having told you so much of me—more than anyone else I have known—could anything else follow but that I should want you—"

She compares him to the canyon; he, the walls she shrinks into when scaling the steep sides, "something I want to be very close to."

"How I understand every pulse, every beat of yours," he responds. "Felt without knowing . . . I saw."

So he dreams of her. The first time is in November 1916. She was asleep, he tells her. He was next to her. "& I saw your hand moving towards something—in its sleep—it touched my hand & stayed there."

v

There are few telephones in West Texas. There are only letters. Often their letters cross paths between Texas and New York. His arrive in one state of mind. Hers leave in another. Then he catches up to her sentiment, but she has moved on. As the months pass, the letters become the physical presence of the one far away.

In November he writes, "You are a very, very great Woman—You have given me—I can't tell you what it is—but it is something tremendous—something so overpowering that I feel as if I had shot up suddenly into the skies & touched the stars—"

The sky, she tells him, is "very big—and dark—and soft—I loved

it—and wanted to go into it." Because everyone she has ever known has "always objected to all the things [she] did . . . she has nothing to lose—Nothing to do but live."

Living, though, does not mean mere existence. Too many around her are blind, scared of what they don't understand, unwilling to act from the belly. He has shown her that. To live means to walk into the void—the dark of night, the hole of sky, the plains whited over by snow.

"I love it," she says, "wish I could be with it now—I want it all— the reality of it makes me almost crazy." She will not enter the enormity of the nothingness alone, for he is already there. "I wanted to walk with you into it."

"I feel rough and wild like the wind tonight—I'd like to take hold of you and handle you rather roughly—because I like you."

A few weeks later, in January of 1917, she does take hold of him. "I wanted you—" she begins. Then, "I wanted you but was too sick to get you out of the envelope."

He responds later that month by putting her in his pocket, where she felt "very alive in there." A few weeks after that he sleeps with her. "I went to bed—and I took you in my arms—closed my eyes—I don't know what happened—Nothing—I don't know—But I felt so at peace I fell asleep . . . and I slept all night & awoke with my arms folded as they had been when I went to sleep."

When this letter arrives, she chokes and can't swallow. She can't read. She can only cry and cry and cry some more. "And I can't read any more—I don't know when I can—and I picked it up and sat there holding it in both hands a long time—so tenderly for fear I'd hurt it—I wanted to kiss it—it seemed made for lips."

He is still married to a woman he despises. He has a daughter, not much younger than she is. She is living among people who despise her and often wants to flee. "I'd like to be a green balloon going up into the sky—the blue sky—and—burst." A war has begun, one neither of them supports. Wall Street has crashed. His gallery is closing. They have the letters and they have the spaces where nothing and everything can be said.

"More—I want—to say—but what—" she writes in March of 1917. "I guess that space is between what they call heaven and earth—out there in what they call the night—is as much it as anything. So I send you the space that is watching the starlight and the empty quiet plains—"

VI

"You get it without my saying," she says.

"You feel the way I do," he says, "not identically—but we understand each other's talk—we need no explanations."

VII

In the spring of 1917 he shows her work in his gallery in New York. It is her first solo show but not the first time he has shown her work. In 1916, before she moved to Canyon, he shared a few of her charcoals with the people of New York. Biographers suggest that she was incensed by the fact that he didn't ask permission first, marched into the gallery and demanded her work be taken down. It was their third meeting. She must also have been terribly flattered. This second showing, a year into their increasingly intimate correspondence, is met with hesitation but not anger. He writes to her that he feels "the world is entitled to a chance to see your work—not that many will get it—but a chance should be given—How many get anything that comes from the real inside?" It is the last show before The Little Room will close. Wilson has just declared war on Germany.

When he stands amid her artwork, he is overpowered. "I felt as if you were running through all my being—as if I had known you for years & years—as if your being had caused every particle of mine—"

When she writes back, it is to say, "What are you to me—I can not say it even to myself—I don't know how—Only I can hardly imagine being without you—space would be so utterly empty."

The show is well received, but the war overshadows the reception. He decides to close the gallery and stop publishing *Camera Work*. "What's the use of Art—if there is war," she muses to him.

Without warning, she decides to take a trip to see him. "It was him I went to see," she writes her friend Anita Pollitzer. "Just had to go Anita—There wasn't any way out of it—and I'm so glad I went." She arrives in New York at 291 on May 24. He immediately rehangs her show.

She spends a week in New York, riding the Ferris wheel at Coney Island, sitting in the gallery with him as the artists who have populated his letters and her imagination come by. One night, while walking, he gives her his cloak to keep her warm. And then she leaves, as suddenly as she arrived. On the day she catches the train back to Texas, he writes her what he could not tell her in person. "How I wanted to photograph you—the hands—the mouth—& the eyes—& the enveloped in black body—the touch of white—& the throat—but I didn't want to break into your time—as I wanted to walk into the night—with you too—I can tell you now—when it can't be."

But it happens. She comes to the gallery before boarding the train and he photographs her, the first of the pictures of her hands, her face, her body that would make her famous, that would turn her into an icon. In his lens, he holds her, as he does her letters.

Over their lifetime, he will make three hundred portraits of her.

Later, after she has left for sure, he writes, "I'm sitting here with the tears just rolling down my cheeks—so desperately alone—& yet so full of life. . . . The train leaves in a minute—Now it is pulling out—I'm chilled to the bone—There goes the clock—Georgia O'Keeffe—Black—White—Hands—Eyes—Smile—"

VIII

It will be another year before they are together again. A year in which the war continues, and he is without a gallery to run, a year in which her art lectures are misunderstood and her paintings kept hidden, her dress a topic of town gossip, her politics questioned, a year in which she dabbles in several relationships, one with a married man, one with a student, one with the artist Paul Strand.

During this time, their letters become more frenzied. More is left unsaid as they try to figure out what is happening between them.

In July she sends him paintings of her naked. "And I wish you were not so far away—and would take me out into the night—way out there in the dark blueness—and that the day would never come." She wants him, she says, "instead of just a letter." She sends him her abstracted body, the next closest thing.

When he receives the paintings, he writes back, "Somehow I'm yearning for the touch of flesh—no desire—beyond the touch—My hand, my mouth—perhaps my own body—Craving to forget all misery & torture—& flesh would do it—a long, long sleep— entwined—I'd like to die that way—" What happened in the ten days they spent together in New York has released a new kind of ferocity in their writing. He dreams of a naked woman, "breasts— near my breast." She wants to have her "breasts close to [him]—and feel that [he] like[s] them." But Canyon and New York are almost two thousand miles apart.

Often their letters are filled with the desire for the other's presence, but neither is sure how to make that happen. He should come to her, but he has jury duty. She should come to him, but she has her classes. And what if there is nothing in the gaps they have cultivated? Neither trusts language, and yet they build a relationship on words, or the spaces between words really. They both insist they are understood entirely by the other, but that understanding is not found on the actual page. Inspired by the far-off cliffs of Palo Duro, she writes, "It's something very beautiful I want to touch—but— wouldn't if I could for fear I might find there is nothing there."

"I hate it here," she says.

"As you feel as if you were preparing to end something—to go— so I have been feeling for months," he responds.

"Help me," she writes.

But neither makes a move.

She says she will remain in Canyon.

He leaves his wife but then moves back home again.

"I'm mad enough to kill," she writes when her lectures on modern art are challenged by the faculty.

"Here I'm again with you," as he opens another letter from Canyon.

"I love you very much this morning," she says. "Isn't that funny to say—I sat here a long time wondering whether I would say it or not—but I wanted to say it—"

He fights with his wife, consults a lawyer, but remains. "I had just come from 'home' where I had an awful row with Mrs. Stieglitz— It's a wonder I didn't kill her—She has hurt me so terrifically for twenty-four years—all that's really good in me she tries to drag in the mud—She doesn't know it—but she is without heart—she can't help it.—And I follow her & listen & try to be quiet—quiet in the sense that someone is lying on the operating table & is being operated on—butchered by a pseudo surgeon—without anesthetic—& finally one can't stand the dilettantism & one is ready to kill the would-be 'helper'—"

The plains are almost enough for her; their emptiness almost completes. "The country is really wonderful," she tells him that fall, "all so flat and empty—a yellow look quite brilliant over it all—I just want it all and like it so much. . . . I went to the canyon— supper on the edge of the plains—the long drop right off the edge—the tremendous stretch between us and the other side— Four or six miles at least—I should imagine—wonderful colors— all colors—the shadows forming—one place where we could see it winding on must have been much more than six miles—so far away that the colors went in with the sky almost. . . . And I don't know—I felt something. . . . I wish you were here—or I were there—or something—"

Almost but not enough.

Then she gets sick. Very sick. Most likely the influenza of 1918. She does not teach, does not leave her bedroom, does not write. "You see, I haven't even responded to the sunrise or the sunset or the bright shining day or the night sky—Other things have been taking so much of me there has been no energy—no vitality for others—I've often looked at things and wished I had the energy or life—whatever

it is that makes you feel things enough to create from them—but I haven't dared to give myself that way lately—There hasn't been enough of me—"

He is crazed with worry, questions her doctor, wants to know the specific diagnosis. The distance between them, once revered because it preserved their perfect correspondence, now takes its toll. He tells her, "Again I felt like wiring—I feel as if letters took an eternity—I want you to feel more immediately what I am feeling *now*—about you—your work, your state—at Canyon."

She cannot remain in Canyon, she tells him. "I am so very sick."

"I'm afraid," she adds.

She leaves for San Antonio under a doctor's order to move to a lower altitude. But her condition doesn't improve. She still moves in and out of sickness. He telegrams repeatedly. He writes. He says, "Today I tried hard to think a little less of you." But he can't. He tells her he is the only one who truly sees her.

"I dreamt I awoke and found you snugly asleep in my arms," he says.

"I need you—as you need me—" he says.

And yet. What if she comes to him and finds him less than his letters. What if she comes and withers in the city. He writes, "Sometimes I feel I'm going stark mad—That I ought to say—Dearest—You are so much to me that you must not come near me—Coming may bring you darkness instead of light—and it's in Everlasting Light you should live in—" And then in the same letter, "Perhaps I'm afraid—afraid that I am steering you for pain."

She and her friend Leah buy a farm in Waring, Texas. It's a last-ditch effort to remain on the plains, to find a place among people who fail to see—to see her, to see the land, to see her art. Late that spring, she writes, "Haven't written—because there is something I want to say and it's hard to say—It's a very simple fact that I've always known but some way has come newly to me—It's the telling me of why I am not fitting into what is around me here—"

She cannot hold her center. People don't know how to talk to her. They take her time and leave her nothing. She is bound, trapped, ready to "fly into a million pieces. Yes—love me very much only I guess don't touch me—"

42

Four days later she writes that she may just need to move to New York. "I'm getting to want to see you so bad."

In August of 1914, she begins it. In June of 1918, she begins it anew. If they are to walk into the night, she realizes, she must go to him. "It has to be that way. I don't know why. I don't know anything. Think I see straight yet see nothing."

She leaps into that nothingness and boards the train for New York, arriving on June 8, almost exactly four years after that first letter.

IX

The brownstone apartment on Fifty-Ninth, his niece Elizabeth's, is two rooms without a kitchen. In the smaller of the two, he keeps his camera, the white umbrella that he uses to "throw light into the shadow," and his photo-developing materials. The second room is painted lemon yellow with orange floors. A skylight captures the summer sun and funnels light onto the bed where she sleeps below. It is so warm during the day that she paints naked. They are together every possible hour inside this ball of flame.

When he photographs her, she says, it is "with a kind of heat and excitement." She must remain very still, her forearms bent on her pillow, her breast peeking out from a thin white robe. Perfect stillness will ensure that the photo has crisp edges. But no one can stay that still, especially a lover, so the photos will have a softness that conveys a sense of touch, inviting viewers to run their eyes, their fingers, their palms along the flat of stomach, mound of breast, elegant curve of neck.

His actual touch is its own kind of fire as he adjusts her thick, brown hair, pulls her robe open, spreads her legs. She cups her breasts between her forearms and offers them to him.

He studies her body through the lens, without sentimentality or romanticism, cropping her curves into the very elements of desire. She bends and bows for him, sweat glistening in the sun. Years later, a writer will remark that the photographs belong as much among her works as his. They are a collaboration, a perfect understanding.

Light pours down through the skylight and the orange floor ignites.

She writes to him, "Can I stand it—the terrible fineness and beauty of the intensity of you—I do not know—may yet have to run away—it seems almost too much—The hot setting sun so brilliant—shining white I could hardly walk toward it—And lying here—wanting you with such an all [over] ache—not just wanting—loving—feeling—all the parts of my body touched and kissed—conscious of you—A volcano is nothing to it—No words I know say the hotness."

More Feeling Than Brain

I'D BEEN LOOKING BACK, behind us, at the dark road already traveled, so by the time Michael cries out—the dull thump of a body resounding against the fender—and I turn to face forward, all I can see is cyclone of limb and motion, thrown clutches of fur flying like dandelion fluff in the headlights.

"What did we hit?"

Michael is already pulling the van to the side of the highway, gravel crunching, then the incline of bank. We come to rest at a slant. The northern New Mexico sky brims with starlight, while the road remains empty, the desert unfurling around us, broken only by butte and juniper. It is four in the morning on a Saturday in March. Our sons, Aidan, six, and Kellen, four, sit awake in the backseat, having been rousted from their sleep only thirty minutes before for the six-hundred-mile drive home.

"A coyote," Michael responds, his hands tight on the wheel.

Did you ever have something to say and feel as if the whole side of the wall wouldn't be big enough to say it on and then sit down on the floor and try to get it on to a sheet of paper—and when you had put it down look at it and try to put into words what you have been trying to say with just marks—and then—wonder what it all is anyway—

45

A week earlier we had traveled south from our home in Logan, Utah, in search of sun and ground without snow. We also went in search of Georgia O'Keeffe or at least the landscapes she painted. It took until northern New Mexico to find both. The narrow cabin we rented sat on the Rio Chama, the same river O'Keeffe painted numerous times, where she described the spring leaves as lettuce and painted a perspective of the river impossible to achieve without a bridge. The Chama forms a major tributary of the Rio Grande; ten thousand years ago, camels and woolly mammoths bent their necks to drink. Cottonwoods and willows closest to the water were tinged with greens and reds and yellows, tiny buds curled in tight. In the morning, the boys' voices would drift down like silt from their bed in the loft above us. We slept on the edge of spring.

Our second morning at the cabin, Aidan found a brochure for Christ in the Desert, a nearby monastery built decades earlier at the end of a canyon cut by the Rio Chama. It was reachable only via a thirteen-mile dirt road, most of which was impassable in winter. The cover of the pamphlet showed the sanctuary, where dark vigas wove across the ceiling and a wooden crucifix carved with the elemental simplicity of the desert itself hung on the wall. Aidan stared at the figure on the cross, then out the windows to the still-bare orchard and sky, then back to the pamphlet.

"What's this guy doing?" he asked Michael.

"Oh, he's exercising."

You see the thing I write you isn't so because—what I think is—so now—can't be—because what I think was—was not—and what I want or think I want—can't be—and what will be in reality will not be for me—So I come to the conclusion that the thing that disturbs me is something in myself because it only exists for me through me as I touch the world—

The wheels of our silver van have only just halted, but I have not been still. Deceleration has hurled me backward in time, so that the slower we move through the desert, the faster I travel the past.

I am standing in my living room in front of the picture window, the Bear Mountains rising to the east, and my mother tells me over

the phone that my father and uncle have been in an accident in the Alaska wilderness and only my father has made it out: a raft down the Alatna River, his dead brother strapped down alongside dry bags, spring waters threatening to overturn them again.

I am walking arm in arm with Michael at two in the morning. Rural Idaho. We head toward a cluster of lights, a covey of mobile homes, where we knock on every door, trying to find the owners of the dog we have just run over. We raise our hands to the last door, perverse missionaries dressed in blue jeans whose only message is how quickly, a flash of fur, it can all change.

I am lying on the carpet of our just-painted nursery, four months pregnant, Aidan's movements still unfamiliar and new. Days earlier, our puppy, Krishna, under a house sitter's watch, had been struck by a semitruck. Pale mountain light streams through the double-hung window, and I am wracked by the image of her soft, black body being scraped from the asphalt by a city worker and thrown into the dump to conceal any negligence.

I am holding Michael on our bed as he grieves his father's death. He howls at the rude orphaning and mourns the father he never had, as well as the one he did. The clock beside the bed ushers us ever forward, and I knock it to the floor for its unwillingness to pause.

All these bodies pile before me, gather on the floor of the van, covering the gray mats and pressing against my door. But Aidan is crying in the backseat, the wheels of the van stopped, fur settled, stars above.

"You have to be strong," Michael says.

I reach to unbuckle my seat belt, feel the strap release and return to its slot above my head. If only grief could be so easily stowed. As I move to the backseat to console the boys, a spark of anger kindles in my belly. A familiar response to a world that refuses to follow the route I lay out each morning.

My old sense of reality seems displaced and I cannot quite anchor a new one—

Our first morning in the cabin, I went running. My route took me

up a mesa just behind our cabin, where I could see the Rio Chama snaking below at the foot of the mesa. Georgia O'Keeffe's Cerro Pedernal rose to the south, the flat-topped butte that stands ten thousand feet high and serves as a point of reference for miles around. Its steep sides appear in many of her New Mexico landscapes, her signature. I have read that her ashes were spread from its summit and imagine particles of her long-circulating body entering my chest with every breath.

To get in five miles, I ran the loop on top of the mesa twice. At six thousand feet, the air was even thinner than the already-distilled air of home, keeping me in my body as I ran, reminding me of basic needs. Several adobe houses dotted the loop, but both my road and the evidence of civilization ended at the fence marking the six thousand acres of public land that stretched between me and O'Keeffe's Pedernal. Five hundred feet from the barbed wire fence, a small butte, jutted and uneven, erupted from the ground. Aside from the far-off mountains and the few houses nearby, it was the only vertical feature in the landscape.

Back at the cabin after my first run, I told Michael about the butte, and he promptly set off to hike it. That morning, from the top of the butte, he looked down and saw two coyotes wandering an arroyo, heading home after a long night of prowling. He told the boys about the pair as soon as he returned, eager for them to see a coyote.

The large white flower with the golden heart is something I have to say about white—quite different from what white has been meaning to me. Whether the flower or the color is the focus I do not know. I do know that the flower is painted large to convey to you my experience of the flower—and what is my experience of the flower if it is not color. I know I can not paint a flower. I can not paint the sun on the desert on a bright summer morning but maybe in terms of paint color I can convey to you my experience of the flower

Once when Aidan was two, he had three yellow balloons in the car with him. When I opened the door, the trio of balloons escaped from his hand and followed the winds up Green Canyon until they

were but dots in the sky. Four years later he still cries for those balloons, will say he can't stop thinking about them when he is trying to go to sleep. It seems he's collapsed his suffering into that one moment, into that single memory of those latex bodies floating farther and farther beyond his reach, disappearing into vastness. No longer filled with helium, they carry all that he can't explain.

I would have told Aidan that the man in the picture was exercising as well. Anything else would have seemed too much. As a parent, I can carry some stories for my sons until they can carry them on their own. I can shield them from what they are not yet old enough to understand. What I am wondering is how I can hold a story for them for which I have no words.

—for the world hurts—Someone to feel it like I feel it—

The entire week we stayed in the cabin by the Rio Chama, Michael and Aidan maintained their morning ritual of setting out after I returned from my run to hike the public lands looking for coyotes. Aidan had never seen a coyote in the natural world, only the ones at our zoo. At the age of two, Michael had given him a stuffed coyote and told Aidan that the animal would keep him safe at night. He never slept without it. Every day of our vacation, he awoke with the word *coyote* on his lips. "Will we see one today, Daddy?" he would ask. "Will we?"

They would pack their breakfast and some hot tea, a pair of binoculars and extra hats, and leave just as the sun reached the mesa top. Before seven in the morning, they would hike farther than Aidan had ever hiked before, climbing to the top of the butte, on hands and knees against the slope, and scan the flat desert. In silence, not moving, tea cooling, they'd watch the scrub for a flash of silver, listen for the rustle of branches.

They never saw one.

you alone know your own truth

Kellen, the four-year-old, is looking out the window of the van into the New Mexico darkness. He doesn't cry. Instead, he says, "Now the

coyote is back in the stars, and when we go back to the stars we can visit him." This is the story Michael and I have created to explain death, though our sons have little immediate experience with that kind of loss. Back to the stars we tell them, those pinpricks of light beautiful and eternal, yet sufficiently distant. Perhaps Kellen is choosing the very star, plotting the coyote's journey from road to sky. He is two years younger than Aidan, and death is even more abstract for him. His stories still end happily ever after, the cocoon not yet cracked

Aidan, though, is inconsolable. I hold him against my body as he cries and tell him that I am sorry, over and over again. I rub his hands, his legs, stroke his hair, his cheek, frustrated that I cannot start the day again, choose a different road, leave an hour later. Michael turns the engine off, though the headlights still shoot into the darkness, twin moons. Thousands of miles of scrub brush surround us. Since leaving the cabin we have not seen another car, another person, another animal. An empty sea of blackness and the coyote jumps in front of our van?

"We have been waiting and waiting to see one," Aidan sobs, "waiting and waiting."

And this, I think, is the coyote he is given.

The light green waves seemed to come out of space this morning after the sun was well up—They seemed to mark off the edge of the earth and the beginning of time and space—or should I say timeless space—

As I ran the mesa top on the third morning of our vacation, the morning we were to drive to the Christ in the Desert Monastery, I thought about how we might explain the crucifixion to the boys. What would the story be that we gave them?

A front had moved in overnight, and the wind blew through my mittens. The day before, we had hiked in the Carson National Forest while it snowed on us, large white flakes that caught in our hair and frosted our cheeks. Michael built a fire under some trees, where we traded apple slices and cheese sandwiches between gloved hands. Today it wasn't snowing, but the feeling of spring had vanished, the air thinner and colder, shorn of warmth.

Michael was raised Catholic, and I attended Catholic school for five years. While Michael has never recovered from the steady diet of martyred saints and bloody crucifixions he was fed as a child, I still sleep with the aborted fetuses the nuns showed in religion class throughout eighth grade. The world, we thought, was bloody enough for our boys without images of Christ on the cross. Now, though, on the day they would stand beneath a crucifix, we would need to come up with something other than calisthenics as a means of explanation.

Today is harder to put down in color than the other days.

The summer before, when Aidan had just turned six, he spent the mornings at the kitchen table where he wrote stories. He knew that both Michael and I were writers, knew that when we were bent over our journals in the morning-dark hours, he should wait quietly on the couch. That summer he kept his stories in a red folder, then put them on the bookshelf in the room he shared with his brother. Sometimes he would take out the folder and read the stories to Kellen.

One day I had a coyote. I got him from the mountains called Green Canyon and when it was night the coyote started to howl. My mom and dad were mad at the coyote. Then the coyote went to sleep. The end.

Every story he wrote that summer featured coyotes. No longer just the animals that chased the bad dreams away at night, they'd entered his days, populated his imaginative play, and spoke and moved in his fictions.

But the living truth is all that interests me—it moves
constantly.—You know what I mean—You are the symbol of the
living truth—you feel the moment—although you may not
understand it.—And still perhaps you do—without trying to—
You just do—

We remain in the van; only minutes have passed. I can hear Michael

breathing. All of a sudden, the night explodes in reds, blues, and whites, a calliope of color that likely sends any creature, the mother's pup maybe, the coyote's mate, running from the roadside and deeper into the desert. Lights circle the ceiling of the van and create a vortex above our heads.

"The police," Michael says.

I look back and see the cruiser, watch the door open. The officer seems to have emerged from the night itself. Michael opens the front door and walks toward the whirling lights. Moments earlier he had asked me if I thought we should go back, find the coyote, make sure it had died. I had said no, that the animal was surely dead, but now I half expect Michael to keep on walking, past the police officer, past the circus of color, and into the darkness from which we have come.

"I know the colors of a police," Kellen chatters. "Red, blue, and yellow."

"We have been waiting and waiting," Aidan cries.

I sit between them, rubbing their legs.

When Michael returns to the car, he tells us the police officer wanted to reassure us that there were thousands of coyotes out there. This death, the officer suggested, was nothing. We both turn toward the emptiness around the van, hoping, I suppose, to see a flock of silver-furred coyotes emerge from the piñon pine.

I wish I could do what I saw last night—the queer white windowless mass—and the terribly alive sky full of stars—the desert stretching on and on like the ocean—dark—

By the time I returned from my run to our cabin, my gloved hands throbbing with the cold, I had settled on *Star Wars* to explain the cross. How Obi-Wan Kenobi sacrifices himself when he allows Darth Vader to cut him down so that Luke, Leia, and Han can escape. Jesus was sort of like that.

But first we had to explain who Jesus was. We went with Baby Jesus and the manger, an image they understood from Christmas displays. Then we had him grow up and die. Just like Obi-Wan. That was what we told them while driving the thirteen miles of dirt road to the monastery.

"Baby Jesus died?" Kellen asked.

"He wasn't a baby when he died," Michael reassured.

The Rio Chama paralleled us as we drove, winking in and out of juniper stands. Red rock lined the canyon, the red found in O'Keeffe's paintings, color ground from marrow. It was warmer outside, though still windy, and Michael drove slowly past the tumbling water, avoiding the potholes left by freezing mud. Outside a bluebird flashed against the dark green.

The earth is so richly colored it seems I could make paint from what I am walking on.

At the moment we hit the coyote, Jai Uttal had been chanting "He Ma Durga" on the stereo. His deep voice continues long after Michael turns off the engine and the police officer arrives and leaves, filling my head, so that I find myself comforting my son with a mantra as old as the juniper around me. Jai Uttal sings kirtan, a chant that dates back to the thirteenth century. The mantras repeated in kirtan are meant to evoke the divine. Roughly translated, the Sanskrit reassures that the Great Mother abides. "He Ma Durga" is a lullaby in our house. We tell Aidan and Kellen it is a song to keep them safe.

The coyote is not safe. He is dead. Or she. And we have killed it. Michael will say later that he hesitated only a moment before telling Aidan the truth.

"What did we hit?"

"A deer, I mean a skunk, a rabbit."

"What did we hit?"

"A branch, the side of the road, the limits of innocence."

"What did we hit?"

"The past, the Great Mother, a toad that was already dead."

"What did we hit?"

"Nothing."

Maybe I should try and paint what I hear rather than what I see.

Ten minutes after the police officer leaves us, we are on the road again, heading north to home, the coyote's body farther and farther behind.

Aidan and Kellen sleep; Michael and I sit in the front, dark still around us, the music off. Aidan sleeps with two coyotes every night, the one Michael gave him and a baby that came along later. He holds one now in the backseat of a silver van with coyote blood and fur on its bumper. I hate a universe that offers us a dead coyote.

Near a tiny town on the border of New Mexico, Aidan wakes and throws up. Then he starts to cry. After we stop on the side of the road to clean his pajamas and booster seat, we turn Jai Uttal back on. In his deep voice, he assures us that the Great Mother still abides, yet I now resist the familiar chant, even as I wonder what other choice exists.

"It's the worst thing that could have happened," Michael whispers to me, thinking, I am sure, that it seems impossible that we have hit the very animal Aidan has been waiting to see. We are climbing out of the desert into tree-covered mountains. Snow has returned, no scrub jays, no bluebirds. The stars fade with dawn.

"No," I reassure, "it's not." And I think about how Michael didn't even have a chance to brake, that it happened so fast. A slower animal, more time to respond, and Michael would have swerved, sending us into a ditch, a guardrail, out of control.

It is sometimes saying something that I probably would have said if I could have—and painted because I can paint things I feel and do not understand when I can't formulate them into words.

We sat under the cross, looking up at the hanged man.

"Is that the Baby Jesus?" Kellen asked, and I nodded.

As crucifixes go, the one at the Christ in the Desert Monastery is Zen-like in its simplicity, mirroring the chapel itself as well as the surrounding land. Because of the large windows, the rock and wood, it is hard to tell whether you are inside or outside. Designed by George Nakashima, a Japanese American woodworker and architect, the sanctuary was praised by Thomas Merton as the most perfect chapel he had ever visited. Tall, rectangular windows frame the clear desert light, so that the canyon walls hang like paintings against the blue sky. We sat on wooden pews, shaped, I imagined, by Nakashima's lathe. An altar made from a slab of canyon rock stood before us. We were the only ones there.

I could hear the wind and waited for the boys to say something about the blood, the holes in his hands, the thorns that pierced his forehead. They were more interested in lighting candles at the small altars.

"Can we make a wish?" Aidan asked.

Michael stood to dig for change in his pocket to pay for candles to light.

As Aidan lit his candle, I looked back at the crucifix glowing in the sun.

The blood came from wounds I could see, rivers of red as dark as the canyon walls. It ran from his forehead and cheeks, chest and arms. On his head, a crown of thorns spiked out in all directions. In the way he held his body against the cross, he didn't look dead, even as the blood ran between his toes. He might have stepped from the wall to walk among us. It was clear the artist wanted the viewer to feel the possibility of both life and death in one body.

I have used these things to say what is to me the wideness and wonder of the world as I live in it.

In Moab, Utah, we pull into the parking lot of a grocery store to inspect the van in full daylight. The boys remain in their car seats while Michael and I take a look. The van's bumper hangs close to the ground. Michael heads inside to buy some wire to twine the bumper to the undercarriage so that it won't drag the road. As Michael secures the bumper with wire, I try not to notice the tufts of fur lodged in the cracks of plastic. The worst damage is on the driver's side. The coyote almost made it—twelve more inches and he would have cleared the van. Shaking our heads, Michael and I get back in the car and tell the boys to buckle up. We still have hours to go.

Michael won't remember this moment at all. For him, it never happened. He didn't lie on the asphalt with his head under the van. He didn't ignore the fur and blood. He didn't bandage the front end of the van back together. We never stopped in Moab.

His story of this moment in our lives is very different from my own telling. I realize how truth slips and slides like tires on a New Mexico highway. Aidan, too, will tell a different version when he

returns. It is one marked by silence, an inability to speak of it at all.

This is a drawing of something I never saw except in the drawing.

On the last night of our vacation, tucked safely in our cabin, the Rio Chama shushing past, we lay together on the two futons in the loft, the branches outside the window clicking together in the dark. Michael lay with Aidan, while I rubbed Kellen's legs. We were sad to be going home, back to the snow and cold, away from running water and the first green spears of crocus.

"In the middle of the night," Michael said, "we will carry you to the car. When you wake up, we'll be driving."

"Will it be dark?" Aidan asked.

"Yes. We'll be driving under the stars."

It would feel like magic, we told them.

Michael began a bedtime story as he always did: "Once upon a time a long time ago, there were two boys named Aidan and Kellen."

Both boys yawned, as if on cue, and Kellen moved closer to me under the covers.

In this story, Aidan turned into a coyote while Kellen turned into a cat. Together they got into all sorts of trouble, eluding a frantic farmer and saving some baby wolves. It was the kind of story Michael told every night, a tale of rescue and safety, one to empower them. But also a story that could never happen, wasn't real, a magical story. Toward the end of the tale, Michael asked the boys if, within that world, they wanted to remain a coyote and kitty or if they wanted to be turned back into boys. Kellen wanted to turn back into a boy.

"I want to stay a coyote," Aidan said, "and never come back."

I work in a queer sort of unconscious way—more feeling than brain.

I expect the snow to be deep upon our return, but a spring thaw in northern Utah has temperatures hovering around fifty degrees, even at five in the evening, when we pull into the driveway, more

than six hundred miles from where we'd been when we woke up. The van has barely halted before the boys run inside to see the toys they had not taken. When Michael and I begin unloading the car, I make sure not to walk past the bumper.

I have made only two trips into the house when Aidan comes outside holding a folded packing box. He has gotten into the closet under the stairs, a place he is not supposed to go, and pulled out one of our saved moving boxes.

"Aidan," I say, exasperated. "We haven't been home five minutes and you're getting into things you know you aren't supposed to."

Tears gather in his already-red eyes, lips quivering. My son stands there on the driveway, box in hand, and says, "I got it for the coyote, so we can bury things for his trip back to the stars."

I want to fill his empty box.

I will probably have to try to get at least one thing that feels like something I feel here—It will be my only way of really telling you of it—

The van has grown cold, even though the heat is cranked to high. I pull my legs to my body for warmth and consider searching the backseat for a coat or blanket. We are driving too fast, though.

The road must curve sharply—though I can't see much out the window. My shoulders pitch toward the door, and I knock my head against the glass.

"Where are we?" I ask. "Are you still following 84 across the border?"

Coyote nods, or maybe he is just moving in time to the kirtan. He won't meet my eyes.

I notice blood along his jowls and down the side of his neck, but the wound appears painted, fixed. Every now and then, he adjusts the lap belt so that it hits below the gash on his leg, similarly painted. Then we are climbing a hill, a steep incline. In fact, we seem to be going straight up.

"Are we leaving the desert?" I ask.

Coyote shakes his head and hunches closer to the steering wheel. The accelerator must be to the floor. Dark shapes fly past the

window, a juniper, a pine, boulders the size of cars. He begins to pant, as though his breath moves the van forward, carries it up the hill. We climb, my head thrown back against the seat, gravity pulling my organs, my flesh, pressing me flat. The speedometer needle has snapped, the pace furious. The window glass near my cheek hums, and the floor mats vibrate the soles of my feet.

Outside, nothing, just blackness.

"I think we should pull over," I say. "Now."

"Just wait," he says, his nose reaching almost to the windshield.

The wheels don't seem to be touching the ground anymore. I can't hear the rhythmic contact of rubber and pavement. In fact, I can't hear anything, no wind, no trees, only the sense of flying through the darkness under a power not my own. "We're getting close," Coyote yells. The exertion has opened his wounds, and blood now runs down his forelegs onto his paws. Up, up, we go.

With one final hurtling movement, we reach the top of the incline and the van spins out across a scrabble of rock and shrub. Far below, the sea of juniper and cactus rolls toward the horizon. We are stopped, and sound returns, taking the place of speed. Thousands of coyotes surround us, all with their heads cocked back, howling at the moon, high atop the Pedernal.

If I could stop, I would howl at the madness of it all, but around me the coyotes begin to run. I run too, don't even hesitate. Long habit takes over, and I keep pace. Coyote runs just ahead. I can see the silver of his fur flash under the moon as we race for the horizon, delirious with speed, lungs and heart open and laughing. I see no path or trail, no route. I follow only Coyote as we speed across the desert floor. When I lose him, I follow nothing at all.

The moon is setting, slipping beneath the desert's skirt, white and shining. I run toward it, moving without thinking, flying through the air. When I leap, the moon appears, for a moment, like a headlight, but just as quickly becomes a plate of light. I turn to see if Coyote has made the jump and find that I am alone. I ride the moon into the darkness, far up into the sky. No ladders. No stairs. Moon becomes star and together we fall, leaving behind a streak of white stardust that seems so thick and vibrant and solid that even a child could see it from below.

Cleaving, 1929

Dear GOK:

Do you remember how you emerged from the train that spring? I would call it exuberant. "I feel like bursting," you wrote. That was how happy you were to have arrived in New Mexico in 1929, returned to the desert you had seen a decade before with your sister. How quickly you stowed any reluctance about leaving your husband. "Even through my tears," you had written to him days earlier, "I knew I had to go." I think you wrote that letter from the train—Stieglitz on the platform waving you west. At least that is how I imagine it: him waving and caped, you at the window of the car, the rumble of engine through the soles of your shoes. Stepping from the train onto the platform that morning, the tears seemed to have dried. Instead, you are recalled to the light, pellucid and thin, recalled to the air, dry, even crackling, recalled to the sun. "I feel like bursting."

I know that sky.

It's all I really see in those first letters—the ones posted from Santa Fe that summer—mountains and sky. Nothing of what you have fled. I look for infidelity and bitterness but only read joy, "turning the world over again," how you "used to feel."

It's all about Before.

That you used to feel differently is as close as you get to naming

the summer of 1929 as the hinge upon which the door of your future swings. Before New Mexico and After. "It is as though I fall into something from which there is no return—no road back—"

Much later in your life you will say you knew that April day that you were coming home, but I think that is what you can say later, decades later, after you have bought a house at Ghost Ranch and renovated a second in Abiquiú. When I read those first letters you wrote to your husband after arriving in the desert, I always have the sense that you were fleeing your center, not returning to it.

If I were to write the story of Before and After, I would begin: Once upon a time, Stieglitz completed you. Or maybe I would go even further back into your past: Once upon a time, it was enough to sit in the hayloft of the barn in Sun Prairie and look across the wide, green fields. Or maybe to tell the story of how the center can't always hold, I wouldn't focus on plot at all. Once upon a time, jimsonweed could say it all.

You traveled so far that summer. *Ran* is the verb I almost wrote. Farther than Texas. Much farther than the beaches in Maine or the Canadian coast, Wisconsin, or even the Carolinas. Two thousand miles falling like fact beneath the rails to Santa Fe. Distance, a canyon splitting the earth.

I don't ask you why. I think I know. But I have often wondered if you would see that summer in the same way that I do. Did it feel like a halving to you?

Sincerely,
J.

Dear GOK:
Today I find myself thinking about what draws me to your letters. I have no easy answer. Oh, I could come up with all sorts of stories that make sense. I could begin with graduate school and run a line to my house in the high desert. I could travel even further back, to high school, and a trip to the National Gallery of Art. For that

matter, I could return to the womb, the first void. Honestly, I stand at the end of a long line of artists who sought your presence, drove the many miles from Española and called to you from your gate. We each have our different reasons—some articulated and others not— but we are similar in one way: we all sought entrance. Into your house, your studio, your mind, your days. Proximity. As if your clear and true and raw way of seeing might be caught, like a cold, and passed on.

I want to sit with you.

I suppose that is one of the miracles of your letters, of letters in general—their residence in the daily. You, as the writer, write from your days and about your days but cannot move into the future. Even when you dip into the past, your memory stands in relation to what is happening right now, a temporary connection.

It's a bit of a trap: dailiness. A trap that snares us all. The past already gone; the future not yet upon us. Nowhere else to turn. The story of a life—once upon a time to happily ever after—requires a distance unobtainable by a letter writer. You cannot step away from your kitchen table and perceive the arc that shapes your days. Like modernism itself, letters refuse the tidy lines of story.

Which means that when I read your letters, I perch on the windowsill and watch time unfold with you.

You, of all people, would understand the lure of that windowsill. I am thinking of your patio door, your pelvis bones, your fishhooks. Time and again, you gave us an aperture through which to gaze. I cannot paint, but I can recognize a window made of words when I see one.

Letters as a window made of words. I like that. In that way, dailiness is more of a gift than a trap. You, as the letter writer, can't move past your days, but you, the artist, never needed anything more than what you could see from your window. You give us presence in your paintings—what it means to truly look—and you give us your present in your letters.

Sincerely,
J.

Dear GOK:

I remember how you describe the first time you saw Stieglitz, in his gallery in New York. You "went into the farthest room to wait." Others in your party had been set on "get[ting] him going." The talk bothered you—"louder and louder until it became quite violent"—so you left. You would say later, "There was such a power when he spoke. . . . He molded his hearer. If they crossed him in any way, his power to destroy was as destructive as his power to build—the extremes went together. I have experienced both and survived. . . . There was a constant grinding like the ocean. It was as if something hot, dark and destructive was hitched to the highest, brightest star."

So many metaphors all at once—and I know how rarely you turn to metaphor in your writing—I attend. Stieglitz as ocean, Stieglitz as storm, Stieglitz as shining star.

I wonder if you ever noticed that even at the very moment you first see him, you are moving away. It reminds me of how you describe your hike up the volcano in Hawaii or hugging the cliffs at Palo Duro: terrified but alive, drawn but afraid.

And I am grateful, so grateful, for the leaving as well as the returning, because letters require distance. Otherwise, why write. Someone always has to be the faraway one, while the other remains at home and waits for the mail. Stieglitz left New York City or Lake George only three times in your entire life with him. Three times. And the distance he traveled was but miles. Which left the leaving to you. And because you could not remain, we have your days, some thousands of pages, their bodies heavy with all that could be said and not said.

Back to that summer, to 1929. You write to Stieglitz in those early weeks, "Things go on in me that are rather difficult to tell about—a curious sort of rearranging of myself—or maybe it is just seeing what is there because of the way it connects to new surroundings—at any rate—it is all very good." The light of the high desert unveils something—it allows you to see "what is there." But you will not name the "there," the mess, the thing that must be put to right. Your heart, I think. He struggles in shadow: "I actually began a letter to you at once in the Room—after I had read—but I stopped—I found all words dead—or worse than dead—damned." His gallery has closed. He worries what will happen to his negatives, his prints, the

paintings he has stored. In the dashes, I read the fear that he has already lost you. A few letters later he will recall the rapturous moment when he photographed you naked in New York, breast and gauze and flesh and bow. "Bandaged," he remembers you. I have always been struck by that image. I think he just means you were wrapped in a sheet, but I think of you bound. That is maybe how he liked you best: tied down, secure in his lens. But that summer you are thousands of miles away, rent with joy.

Like those early years in Canyon, you go on these long walks, alone and with others. "I seem to be hunting for something of myself out there—something in myself that will give me a symbol for all this—a symbol for the sense of life I get out here." It will take four years for you to find the bones and, later, the hills. To offer the hole in a pelvis as a self-portrait. I know this now, but you do not know it then. Just wait, I think, you will find it. Keep hunting.

Your ecstasy in these letters is palpable. The desert hums with energy, pulls you toward it. You walk in the mornings, the afternoon, late into the evening. You write, "The mountains and the scrubby cedar were so rich and warm colored they seemed to come right up to me and touch my skin." In the face of such power, such awe, you want to take your clothes off and "lie down in the sun naked." Light, like lover, reaching toward your center, letting you know you are alive.

Am I pushing too hard here? Am I seeing this summer as something more than it actually was? I think not. The tension is building, the distance more and more pronounced.

Sincerely,
J.

Dear GOK:
Okay, I have found more evidence to support my reading of the summer. "Dead in every way." That is how Stieglitz describes the photographic negatives he has burned in a bonfire of bitterness. His work in flame, while you are penetrated by light. "I have already lived all what is going to happen," he tells you. He waits for a jury to return and hand over the verdict on his life. You lie naked in the sun

and he reminds you of your union eleven years ago amid thunder and lightning and wind. "My Holy Mountain invisible within." (I read bandaged here—unfair?)

You, the mountain within, sacred but contained, present but invisible.

And the mountain won't write, at least not often enough. Because the mountain is having "the sort of day that seems to float in space like a perfect thing." So there are long periods of silence. Days when no letter arrives for him. When letters do appear in New York, they say things like, "This seems to be my world and I can't help it" or "I can't go into it all" or "I can really only tell you such a little of it."

You have taken your own lover: the land that "touches something in me that I so like to have touched." He will stupidly—intentionally?—send you letters meant for his lover, letters to the young, dark-haired Dorothy Norman. And you will walk the desert flanks.

Oh that must have hurt. Passionate words addressed to another. Does desert enough exist to walk off that kind of pain?

How ironic that it is now that I begin to think of myself not as scorned woman but as letter reader. Not the intended one, not the first of the intimates, the Dear, the lover, the one waiting in New York for the mail. But the one reading almost sixty years later in my own kitchen, refrigerator compressor coming on, husband digging through his backpack, October light rekindling leaves that have long given up their summer brilliance.

In some ways I am Dorothy Norman. The second reader.

Like her, I arrive without invitation from you.

I want to see the summer of 1929 as the cleft, the cleaving, the very moment when you first saw the fissure running from forehead to belly, the black-cracked lightning ripping you in half, and so I read your pages with purpose. I highlight and bury and bend an arc that would have been unknown to you. My shaping hand is not innocent. No storytelling is.

What motivates me to see you as both cliff wall and chasm? Is it because my first husband cheated on me, and I have no patience for your own husband's preoccupations with beautiful, young women?

(My god, I think, what a cliché.) Or is it my own penchant for tidiness that causes me to focus on one summer and seize that as the bridge? I do, after all, live by my day planner. And I can't tolerate dishes left in the sink. Or is it something I read in a biography once: that your life was a constant struggle between emotional landscapes and physical ones—Stieglitz and the desert, splitting you in two.

I could point out to my own reader, maybe also sitting in a kitchen rinsed with fall color, that you are not merely halving. Connection remains. You want to kiss your husband. He writes you, "My Sweetest heart in her element—Faraway still right here." But I don't. Instead, I clear a path not possible in real life.

Here is what I know: the letters that the two of you exchanged in the summer of 1929 are some of the most passionate, painful, and riveting letters of your entire correspondence; they are remarkable in the ways they detail the physical, emotional, and metaphoric void that separates the two of you; and they document a threshold moment in your life: the (re)discovery of both the desert and your independence. But such an understanding can be gained only by distance—by the kind of distance I have as a reader. You write with blinders on.

Sincerely,
J.

Dear GOK:

Sometimes Stieglitz just makes me angry. He acts like a child, a child having a tantrum, wanting his favorite toy (a toy he will then ignore, or, worse, berate). Later in the same summer, he writes that he is a "dead useless thing." Compared to you, he is "not even dead." He burns old issues of Camera Work by the wheelbarrow-full. "A marvelous yellow" he says of the flames. "A marvelous cremation." A suicide by proxy, he consigns his work to the fire. On the very same day that he burns, you write that you are "feeling remarkably like me." It isn't that you don't care. I think you can't.

"There is nothing for me to say—It makes me feel like being there and trying to take care of you—but I know so well what that leads

to—too—so I am here—" What does your care lead to and too?
Look at all those dashes, all those empty spaces on the page. I will
fill them in for you with your own words. "Something hot, dark and
destructive."

As the summer continues, the tension only increases. The mail
simply cannot keep up. He writes of death. You write of sunshine.
Were I to sit in your living room and watch the two of you tear each
other apart, it would be louder but it wouldn't be as intense. And that
is because letter writing happens not only across space but also across
time. Writer and reader never occupy the same space geographically
or temporally. That distance can fuel passion as it does in your
Canyon letters, but the delay can also create gaps where anger,
misunderstanding, and confusion take root. So as I move into June
and July of that summer, the distance between the two of you cannot
be measured merely in miles. You walk different worlds.

I wonder if it is even possible for me to understand what it's like
to maintain a relationship through letters. In this age of instant
access, can I truly fathom days of not knowing. I get on Facebook,
and I learn what a friend ate for breakfast. I can even see her plate
of bacon and eggs arranged on her kitchen table, photo posted and
tagged. When I read your letters from that summer, I realize how
the medium itself amplifies the emotional distance already growing.
At the same time, I bear witness to pages where each of you has the
time and space to write your version of the day. Letters arise from
space, letters magnify space, but letters also allow for space, in a
way most of our communication today does not.

You go to Colorado and do not get your mail, so Stieglitz plots his
death, makes funeral arrangements, gets his finances in order. He
asks one favor of you: "the blue and white drawing—that I wish
cremated with me." He explains what he has bequeathed you and
how you can support yourself. Bids you to keep this letter so that
you will know how to dispose of his things. "I must assume," he
finishes, "that you are occasionally giving some of these matters a
thought in spite of Taos."

Fifteen letters wait for you upon your return, but your response
lacks any sympathy. "What I feel you going through made me feel

very sad too." In almost the same breath, you say you are leaving on another trip. "With things moving so fast, this is the best I can do." You reveal you have bought a car and learned to drive. The classic symbol of American independence. "So we are quite free to go about when and where we choose." And then, "—Now that is the way I am—if I had been alone I would have done it years ago—I think you should be glad whether you are or not."

"If I had been alone," you write, suggesting that you have given some thought to what your life might have been like had you not taken that train to New York. I am also drawn to that dash before your sentence begins—the dash before "Now"—in which the possibility exists that you will just keep driving. Not quite a threat, but a silence, an invitation for your husband to object.

A place has taken his place in your bed—at first New Mexico is "the next best thing to being in bed with you"; now the land beckons to be the only one.

You could not absent yourself more fully from his life even through your very death because you have chosen this. It will be some weeks before he can name in his own words the realization that you may have found a life without him. "You really do not need me anymore." Still, there is a cruelty in your letters that I find hard to read. "I cannot live this life of torture," he says, but his confession gets no reply. You are already gone.

At the time, I imagine you were just seizing the opportunity to travel, maybe welcoming the respite from his black mood. Nothing in your letters suggests you were seriously considering leaving your husband. At least not permanently. But you are flirting with the idea. Testing it. Pushing against the possibility like a writer pushes against a metaphor. Does it hold?

Sincerely,
J.

Dear GOK:
Now that I am thinking about absence, I am noticing other voids as well. Not just the spaces between letters. Other unsaids.

You never kept a diary, so your letters provide the only window into your days. Many might argue that your paintings are the closest expression of yourself, but your paintings were always meant for a viewer, for many viewers. They came into the world on stage. After the diary, the letter is the most private of documents. It is, in most cases, meant for one: the Dear. In letters, the degree of intimacy (ah! Yet another kind of distance!) between the writer and the reader is very short. Almost nonexistent. The writer does not need to explain context, relationships, histories. All of that information is already known. They are so intimate that they often cannot be understood by others. Personal letters develop their own codes. You, for example, rarely address your husband in the salutation. He rarely addresses you. Your letters just commence, as if resuming the conversation that ended in the last letter, those hundreds of letters really just one letter, stretching from 1916 to 1946. You have code words as well—Miss Fluffy, your vagina. Little Man, his penis. And pictures, too, arrows and circles for penetration, even orgasm.

The irony I see in your letters, though, is how in this most intimate of forms, the sending of bodies through the mail, you so rarely address the difficulties that plague your relationship. Anger, pain, frustration is all in action: burning, walking, driving, leaving. Sometimes it resides in dashes and white space. Seldom in words.

A correspondence that spans thirty years and not a single letter lost or redacted. In one of the most extraordinary leaps from the private to the public, your intimate thoughts untethered from a single reader and released into the world. In all those pages, so rarely do you name the specifics of your pain. Is it that your relationship is too complicated for words? You have both covered this territory so many times in person that the idea of facing it on the page defeats you? Perhaps I need to gaze at your crosses, your barns, your rived hills.

His madness piles up in your mailbox in New Mexico while you head out on another camping trip.

He writes: "I am not writing. Cannot possibly express what I have to say."

He accuses: "You don't feel like writing? It interferes with your freedom?"

He worries: "So little light for me in the future."

He threatens: "There is no escape for me."

He begs: "I ask for little.—It has come to asking.—You see the degradation—"

I know you are angry. Who wouldn't be? His pain is almost overwhelming to me as a reader sixty years later. But I find so little evidence of your own suffering. His is everywhere. Where is yours articulated? Normally I would look to your artwork when faced with such emptiness in your letters, but you painted very little that summer. Part of that is how much you are traveling. Part of that is because it takes time for you to claim a place. But I think part of that is your unwillingness to be still and let the sadness settle across your shoulders like a sweater. You are on the go the entire summer—traveling, camping, hiking, packing and unpacking. More importantly, I also know that three years from now you will collapse, be hospitalized, and face the possibility of never painting again. The few letters you write during your convalescence, like the canvases you will not fill, will be almost entirely blank.

Because you do not name your pain aloud, I will see your anger in your unwillingness to engage with your husband's madness. When you return from a trip to read the page where he says, "Without you I am nothing," you respond, "Well, I am sorry you worry so about me—" Then you describe your wonderful day. You casually suggest that he might be "a bit mad." You worry you will never sleep.

"But I did—"

Because you do not name your suffering in your letters, I will look for it in other places. That summer you do paint Black Cross, New Mexico*—one of the few paintings from that trip. When you describe the painting to Stieglitz—a strong black cross, cropped and foregrounded, with roiling landscape behind it—he says, "I don't need to see the painting itself—for I know what it looks like. Georgia."*

I know that you and a friend came upon the cross one evening while walking the desert. A Penitente cross, it was still being used to hang pilgrims as a way to expiate their sins.

An image of death held up against a landscape that seethes in color, refusing to be stilled. What I am unsure of is just who or what is being sacrificed.

That is how I want to read that summer—the stakes that high. This moment of choosing—a moment in which you decide your future—not unlike the moment when you board the train from Texas—only this time, your eyes are wide open.

Sincerely,
J.

Dear GOK:

I think I am almost done writing to you about that summer. You are neither victim nor perpetrator. You are neither made nor broken. You are always both/and. Aren't we all?

Because you write to Stieglitz finally and tell him that you will come home if necessary ("All I have to say is—I am feeling very strong and level—and if you cannot get quiet and get yourself together—I will be back to you—"), he begins to feel better. At least I think that is what you assume has made the difference. His letters become, for a moment, lighter and breezier. Really, it is the presence of his lover Dorothy Norman that returns your husband to himself. He will say that she saved him that summer.

I can't help but think of dramatic irony, the literary device where the readers know something the characters do not. We twist in our chairs, writhe and worry. Authors love to use dramatic irony to heighten the tension for their readers, so that the story does not rely simply on plot. It is elegant, like a knife blade rather than a cleaver.

As your reader, I shake my head. What will you say when you discover that Stieglitz and Norman have grown terribly close over the summer? I think about you walking under the stars at night and feeling so alive. Your ecstasy reminds me of the Georgia I met earlier, the one who came to the plains of Texas and thought she might die from the nothingness of it all. And yet I know, I know. In

three years you will be hollowed out, shelled, each empty canvas,
each empty letter a small suicide of its own.

As I read your letters, I am struck by how I am both nearby and
far away. Like your landscapes, there is no middle distance. I am
with you in the beating heart of the present; I walk with you under
the bowl of sky. And I am sitting in my kitchen, sixty years later,
knowing that you will be in the desert once again when your
husband falls to the ground, halfway between your bedroom and
his, and never regains consciousness. You will carry that guilt for
the rest of your life, like a letter in a pocket, like a stone in the hand.

Still, you are not fooled. You know that something has been lost.
Starting in early July, you try to name it. In one of your most
moving letters, you try and describe how things fall apart.

You really need to have no regrets about me—you see—I have
not really had my way of life for many years—when I felt very
close to you—that there was a home for me really within you—I
could live—I will say—<u>your</u> way as much as it was possible for
me to live <u>another's way</u>.

But when that seemed gone—there is much life in me—when
it was always checked in moving toward you—I realized I
would die if it could not move toward something—Here it
seems to move in every direction—There it didn't seem to move
at all—it seemed only to meet cold—cold—

Stieglitz idly threatens to kill himself. Considers jumping from a
plane. Takes poison to bed with him.

If there is any question about whether, in the summer of 1929,
you considered taking the desert as your lover while your husband
chose another, I would point to what you write on July 11: "Months
and years had gone by—and I could not get close to something I had
been close to and touched in you—you did not seem to need the
center of me touching your center—the next best thing was out
here—"

More startling still perhaps, in that same letter, you write, "An
untouched whiteness has been soiled—maybe it isn't a very practical
thing to try and go through life with—Maybe blackness is the pure

*thing after all—the thing you cannot soil—" You are telling him,
right there on the page, that nothing remains pure and untouched.
Not a sheet of paper, not a whitewall tire, not a marriage.*

*It gets ugly. Even though you confirm to him that "there is a
bond" between the two of you that is "deeper than anything you can
do to me" and promise to remain with him ("whether I choose it or
not"), he suggests that you have made your choice between him and
the desert and that he has lost. "You have a new vision—a new
star—guiding you." And then, "If you had no reputation—had no
money—I wonder would you feel all the certainty as you do." He
has made you, he reminds you.*

*Because the letters keep coming, you assume the bond remains. It
won't be until you return to New York in August, that you will see
how much has been lost. Here is the thing. I want you to return.
Even though I know what awaits you, the pain, the collapse, all of it,
I want you to return. I am starting to understand that this summer
is less about you choosing Stieglitz or the desert and more about you
choosing to live between—that space that exists between when a
letter is sent and a letter arrives—when the words are formed and
beating but have not yet been read. That space is both black and
white, bound and free, near and far away.*

Sincerely,
J.

Dear GOK:
My last letter to you. I begin like this—

*At the end of July, Stieglitz writes in an apparent state of peace.
Reminiscent of the letters he wrote in your early courtship,*

hyperbole abounds. "The stars over your head would have told you—every one—had you looked—really looked—the moon would have echoed it—The sun spoke in loud tones—Georgia, he loves you as no woman was ever loved—As woman & artist— One! Georgia! I love to say. Georgia—How often I said it & no echo—I listened and listened—Not a sound—But all is different today."

You think, I am sure, that the change has come about through your honesty, through hard words and painful revelation, but, as Sarah Greenough reveals in My Faraway One, *the world is different today because he has received a particular letter from Norman. A miracle he calls it. Now he can't encourage you enough to stay out west.*

You reply to him: "As I read your letters today I felt myself flow out to you with the old soft beautiful kind of feeling of love and the necessity for you and all that you have meant to me—It was a great relief—as tho some terrible thing has passed."

But the terrible has really only just begun.

You think something has been healed. That the desert had given you back to yourself, returned you to the one you were before "I gave up myself to you." That the mountains and the sun touch "things in me way beyond what I knew I was before." You "know" that he "cannot hurt [you] anymore." But the land can only do so much. Desert is not lover, is not husband, is not all.

You leave again, this time for the Grand Canyon, and are out of communication for days. Norman tells your husband that you are irresponsible and careless. He becomes enraged and declares that he is "unfit to have any relationship with one like you." Then he continues: "As long as you are getting what you want—your new thrill—your new experience—as an artist—as woman—or both.—I have nothing to say. Any more than I could say anything about the hailstorm with hail as large as golf balls that ruined crops & killed cattle. One is merely an onlooker—& knows how helpless one is in final analysis."

73

For him, your merger is complete. You have become the land. You are beyond reason, beyond hope.

"If you ever receive this letter it will be the last you'll get from me." With those words, he cuts you loose. "If you ever receive this you are free—completely so—& the Far West will be yours. And you part of it.—From the very beginning there has been a battle raging . . . between the Far West & what I am—" On August 18, 1929, Stieglitz surrenders in a war that perhaps only he was fighting. He sees it as a battle between him and the desert for your heart. But I now understand there was no choice for you. Time and again, you claim both the emotional and the physical as your center. Though both threaten to destroy you, you never turn away. You always return.

It's not that you are split that summer, cleaved in two. It would be more accurate to say that in the summer of 1929, you first realized the necessity of founding your wholeness on contradiction. When I look at your paintings, I see rifts but rarely separation. Your letters, always sent from a distance, a lasso to home. And maybe that is the wonder of cleaving. It means both split and bound.

No wonder you wrote so many letters in your lifetime. Long after the ubiquity of telephones, you still chose pen and page. You sent yourself in your letters, your very body, but you sent them from afar. In that way, they confirm both presence and absence, intimacy and distance, independence and connection, the nearby and the faraway.

Of course you return to him. Just as you will leave and return to him almost every summer for the rest of your relationship. I am coming, you telegram. I am coming. He is your ocean, your storm.

Your reunion that fall, by all accounts, is sweet and satisfying to you both. In the afternoons, he photographs you with your car, your head next to fender, your hands articulated before rim. After the photographs he made of your early years together, these are considered his best. They are done with love and care and passion.

I, of course, focus on the car.

Sincerely,
J.

Taking Myself to the Sun

"Is it logical you would be walking around entirely orphaned now?"

—*Kabir*

I LOST GOD AND my first husband on March 5, 1995. Together they walked down the Jetway at Honolulu International Airport and boarded a plane bound for Wisconsin. I was twenty-four. My not-yet-ex-husband wore a Packers sweatshirt and matching baseball hat. God was dressed in the same white robes he had been wearing almost fifteen years earlier when I took Jesus into my ten-year-old heart in the Quonset hut that served as Sunday school for Subase Chapel. Over the next few months, I awaited calls from both God and my soon-to-be-ex-husband, hoping they would return to me. Sometimes the phone rang. More often, I sat in silence. The last time I talked with either, I was sitting on the tiled floor of the lobby in the Ilikai Hotel, the cord of the pay phone garroted around my neck.

"I can't do this anymore," I said, and I hung up.

The Utah Climate Center recorded fifty-three lightning strikes in two hours on August 8, 2013, all touching ground between three and five in the morning. For weeks the fire danger had been extreme. Like the rest of the West, northern Utah had been in a severe drought for close to a decade. A year earlier, the forest fires had been so bad that the air in Cache Valley became nearly unbreathable. Smoke passed for sky overhead, gray and dark. In early afternoon, streetlights came on. The young and old were exhorted to remain inside because the particulate matter rivaled levels in Beijing. August passed under ash.

No one saw these fires start; no one witnessed the seam of sky rip open. The strikes landed in the hills above the small towns of Millville and Nibley and set the brush smoldering. By noon the following day, a Sunday, the two fires had merged and consumed 250 acres. Within four hours, the fire had devoured twice that ground.

Looking back, I suppose, there are always signs. An unexplained absence, a pocketed slip of paper, silence at dinner. I don't know what she would name as the first moment she knew something was amiss. I couldn't even say for myself. The first time O'Keeffe leaves her husband for any length of time is the summer of 1922, when she travels to the coast of Maine. That is the same summer Stieglitz began taking nude photographs of his adolescent niece, Georgia Engelhard, as well as nude portraits of the beautiful Beck Strand. ("When I make a photograph, I make love," he said.) Perhaps she had simply grown tired of managing the house at Lake George. She just knew she had to go, the kindling almost imperceptible.

She had been with Stieglitz in New York for four years by 1922. They had spent time at the family house on Lake George that spring, his relatives demanding and loud. The suffocating green of trees and her grating in-laws had most likely put her on the train to York Beach that May, not his indiscretions. Though those quickly followed. Beck Strand in 1923. The cook in 1926. Each time she suspects

the intimacy between her husband and another woman, she heads for the ocean, great reaches of blue and wave.

These dalliances clearly hurt or why would she feel the need to leave their home? On one such flight, O'Keeffe writes her husband from the train to York Beach that she was "nobody—nowhere" but that she "saw things passing the window and I suppose that was me—and the things that I saw made me feel that something that you and I are together is very far away—and I seem to shrink from everything else."

"A black ugly wall" has arisen between them. Stieglitz admits, "I know I am always doing many thing that you'd rather not have me do." He adds, "I also know that as far as the young are concerned I'll keep my hands off—"

The water, the constancy of wave upon sand, the magnification of light and sound—"such masses of froth and foam rushing and rolling and booming till everything seemed to shake"—reawaken O'Keeffe each time she visits the coast. Reassurance, she writes Stieglitz, is something "that the ocean gives me—and the sky gives me and the sand gives me." Land and sky and light also grant her clarity. Before returning to her husband in 1926, she writes, "It must be because I am turning a page in my life—and I must see as clearly as I can what it is—not what I want to see—but what it is."

This is the moon on the sand.

This is the bend of a tree.

This is the man I married.

Months before my not-yet-ex-husband and God took the red-eye to Madison, before I had received the phone bill listing call after call to her, before I translated his "need to be alone" into their secret rendezvous, I went to a reading at the Episcopal church in downtown Honolulu. Madeleine L'Engle spoke. I hadn't read any of her books, but I was keen to join Saint Andrew's Cathedral, which was sponsoring her visit. We gathered in a building adjacent to the cathedral itself, so I wasn't sitting in the room shaped like an

inverted hull and built to the biblical dimensions of Noah's Ark. Instead, I sat on a folding chair, notebook in my purse.

When it came time for the audience to ask questions, I raised my hand.

"Can I be a writer if I have never suffered?"

"Write," she said. "The suffering will come."

At the time, I felt dissatisfied with her response. I think I wanted her to tell me that if I hadn't contracted tuberculosis by the age of twenty, I would never be a writer; therefore I should just quit now. Foolishly, I thought I knew the parameters of my life. Years later, though, I wish I had asked a different question: what to do when the suffering arrives.

By Monday the Millville fire had consumed twenty-five hundred acres and was only 10 percent contained. Over a hundred firefighters had arrived on the job, including two Hot Shot teams. Air tankers and helicopters dropped thousands of gallons of water and phosphorous fertilizer on the flames. The clouds of smoke could be seen from anywhere in the valley.

Grass fires and brushfires burn quickly because of the low moisture content and low flash point. Wood must be heated to 572 degrees before it will ignite, while grass kindles under a magnifying glass. The terrain above Nibley and Millville was rocky and difficult to traverse, limestone cliffs and boulder-strewn fields. Difficult for humans, that is. Fire loves an uphill slope, loves to chase the shrubs and brush it has already preheated in its path.

That fires have so much fuel to burn is the result of a US Forest Service policy committed to extinguishing every fire that blossomed. In the early decades of the last century, Forest Service chiefs called for aggressive action against all fires to protect the forests and the nation's economic well-being. The "10 a.m. policy," which stipulated that forest fires had to be contained by ten o'clock on the morning after they began, has resulted in a heavy fuel load, a deadly load, in our national forests. Where before a fire might have cleared

the underbrush and left the trees, affording the forest room to breathe, megafires now consume everything. They burn the scrub, the trees, the canopy, quickly and without discrimination. Even the smallest of fires often can't be contained by breakfast the following morning.

By the end of the second day, the Millville fire showed no signs of stopping. Fires require fuel, heat, and oxygen. And this fire had plenty of all three.

Dorothy Norman arrives at Stieglitz's Intimate Gallery in 1928, and O'Keeffe goes to New Mexico for the first time in the spring of 1929. There she promptly falls "into something from which there is no return—no road back." The desert Southwest becomes O'Keeffe's lover. Norman becomes Stieglitz's.

Norman is younger than O'Keeffe, married, a mother. She is not talented like O'Keeffe. Cannot reveal a flower's flowerness. Nevertheless, Stieglitz tells Norman she has saved him—from *what* is far less clear.

When he writes to O'Keeffe in the summer of 1929, it is to rehash past wrongs. He burns his own photographs, threatens suicide, makes extravagant plans for his funeral. She refuses to relive those pains, all those moments that put her on a train, sent her back to bed, turned her insides out. There is too much sky, too much red, too much blue. In July she urges him to "leave your regrets and all your sadness—and misery." She continues, "If I had hugged all mine to my heart as you are doing I could not walk out the door and let the sun shine into me as it has—and I could not feel the stars touch the center of me as they do out there on the hills at night." Then she heads for the Grand Canyon, attends corn dances, learns to drive a car. It is only in 1931, when she returns to New York from another summer in New Mexico and comes upon Stieglitz photographing Norman in the nude in their bedroom, that she realizes just how little regret her husband has held on to.

I never saw her naked. Never arrived home to find my husband gathering another woman in the curve of his lens. But I found cum on the sheets on days I had been gone and watched the gas gauge shrink on days he was supposed to be home. I remember a wedding shower, sometime in the spring before he left me for her. I had been there for at least an hour, when my own Dorothy arrived. The buttons on her blouse were askew, the tail untucked, her zipper peeking open. The bride-to-be told me she hoped her marriage would be as strong as mine. Dorothy's pale cheeks flamed red.

I have sat in a hotel where I knew my husband had fucked another woman—possibly on the same bed, under the same fluorescent lighting. I have traced the water stain in the ceiling with my eyes, buried my face in the bedspread searching for his scent. Is this the view she had? Did he hold her the same way he holds me? I know where all the rage goes. I can chart betrayal's path. It burrows deep inside your body and urges you to beat the floor until the blood vessels burst in your palms.

On Wednesday, the Millville fire reached its apex. A "full mandatory evacuation" order was given for the canyon. More helicopters and fire engines arrived. Close to three thousand acres had burned. The former head of the Logan Hot Shots was quoted in the paper as saying he hadn't seen anything like this in his thirty-year career. People drove their cars out toward the canyon and sat on the road to watch a circus of flame.

Biographers are quick to blame the fiasco at the Radio City Music Hall for O'Keeffe's collapse. Or they point to Stieglitz's refusal to

have children. Or his controlling nature. Or the fact that he showed his nudes of Norman in February 1932. And while these are all certainly sites of damage, it is returning to her home to find her husband photographing his lover in their room that turns her body into a "battlefield terribly torn and dug up." She flips on the light and there they are.

Here is what is. Your husband has taken a lover and made it public. He has touched her belly the way he once touched yours. You are no longer the only one, perhaps never were. No amount of sky is going to return you to yourself. You cannot pretend the stain on the sheets is water.

In the hospital the doctor will not allow him to visit. You will not write, not paint, not even go outside. You tell him later that summer, "You see—there isn't any point to doing anything unless it is real like the earth and the sky—or the touch that means something."

You sit on the couch and never turn the lights on. You claw the translucent skin at your wrist. You run the streets of Honolulu in the early morning, before the sun comes up, and will your body to disappear.

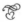

In graduate school at the University of Michigan, I added beauty and truth to the suitcase in which I had packed God. "Nothing exists outside of language," I intoned like a mantra. In postmodern theory, language creates reality. It is our chief, even only, access to truth. In search of certainty, I underlined sentence after sentence in my books. I also drank a lot of coffee and used words like *interpellated* and *liminality* and *heteronormative*. Living by myself in an apartment three miles from campus, I would spend entire days without uttering a single word.

I met Michael, my future husband, at the copy machine in the English Department office. An outlier in a black-clad throng, he wore a pink button-down. He offered to interrupt his print job.

A poet himself, he was writing on Walt Whitman and the idea of conversion. His dissertation consisted of thousands of words

trying to describe the indescribable moment when one touched the face of God. Conversion, a turning, away from and toward, always happened in a moment of ecstasy—a joy beyond language. Michael studied nineteenth-century America, but really what he studied were those men and women from the past who stepped forward with their hearts in their hands, trying to name the moment when they realized that everything was connected.

When I was a child, maybe ten years old, my family came upon a forest fire in the thick woods of northern Virginia. We were the only ones on the road, my father and his sister in the front seat of the car, my brothers and I in the back.

"Stay in the car," my father said. And then he and my aunt headed for the woods. As he walked toward the flames, my father pulled his T-shirt over his head; then he and my aunt merged into the smoke, swallowed.

I didn't stay in the car. I opened the door and followed after my father. The closer I got to the flames, the hotter my skin grew. Once in the smoke, the fog thinned and I could make out the details of the landscape. The fire began at the side of the road and flew up the hill. The flames were chest high, licking the oaks and maples. My aunt and father had waded into the river of fire and were beating the flames down with their shirts. Their faces were already burned red, and sweat ran down their cheeks. Black streaks cut across their arms and legs, marked my father's naked back. With each step, I was sucked deeper into the esophagus of flames.

"I feel like nothing."
"Nothing in me."
"I am only a vacancy."

Michael took me on long canoe rides down the Huron River, where he pointed out the great blue heron and the kingfisher. We sat by a lake for hours to watch an eagle fish. He explained why aspen leaves flutter, unlike those of oaks or maples, and how to build a fire in the snow. One wintry afternoon, we were hiking through an empty woods. The trees simplified to branch alone, veined against the sky. Gray and brown surrounded us, winter's palette; I kept my eyes to the snowy ground, expecting nothing. Just as we entered a clearing, a flock of cedar waxwings burst from a tree. They filled the woods with their gray-and-lemon-yellow bodies, like so many sparks igniting the air.

"Everything that really matters—both our joy and our suffering—" Michael said, "happens outside of language. Just look at the sky."

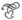

In *Man's Search for Meaning*, Viktor Frankl gives us three possible sources of meaning in our lives. We can invest ourselves in a significant work, we can love another entirely, and we can have courage during difficult times. A survivor of the concentration camps, Frankl describes how he followed all three paths to endure the inhumane conditions of the camps. Of the three though, love is what kept him going, the love of his Beloved, his wife.

Midway through the autobiographical section of the book, Frankl describes the day when he first realized that "the salvation of man is through love and in love." He was marching in a line of barely living men to the work site. The guards yelled and pushed, called them "pigs," and the searchlights blinded. He stumbled over rocks he could see as well as those he couldn't. All around him men fell to the ground. The wind tore through what little clothing they wore. In such distress, such hopelessness, Frankl thought of his wife. He began talking with her in his head. He watched her smile and tease. He did not know if his wife was still alive. She had also

been taken away, but he realized, at that moment, that his love did not depend upon her presence. In fact, his love moved beyond her physical existence, transcending her actual life. "Nothing," he writes, "could touch the strength of my love." No matter how bereft a person is, Frankl tells us, he may still "know bliss" by contemplating his Beloved. He ends the section: "Set me like a seal upon thy heart; love is as strong as death."

We sat in a circle, five of us, black meditation cushions strewn about the room like fish left stranded on the shore. At the Cache County Jail, blue was the new black. Beneath their jumpers, the women wore T-shirts, orange Crocs on their feet.

"It's raining out today," I told them. Our time together had just begun. I had chanted the Sahana Mantra, seeking protection while we gathered, and the final *om* still resonated in my chest.

"The clouds are gray and fill the sky. You can't even see the mountains." Each week my weather report arrived like the evening news. The inmates had no windows, could not see sun or cloud.

Brianna spoke. "Last night when I came back from dinner, all the women in my pod were sitting with their ears to the wall."

"What were they doing?" I asked.

"Listening to the rain against the building. You can hear it if you press your cheek to the concrete. We didn't know if it was rain or hail, but we sat there until it ended."

At that point, they had not been outside for five weeks.

"It was beautiful," she said.

"The rain?" I asked.

"No, all those women with ears pressed to wall."

Jean Toomer will call it O'Keeffe's second satori, the Buddhist term for the moment when you truly see yourself, your true nature, and

are redeemed. The first awakening, he implies, happened in South Carolina in 1915, when O'Keeffe first began to paint for herself, when she sat astride large sheets of paper on the floor and painted all she was "unable to find words for." The second awakening is the moment she claims the battlefield that is her body.

Toomer and O'Keeffe had already been friends for several years when she invited him to stay with her in the house on Lake George in December 1933. She had only barely left the hospital and was in a fragile, distilled state. He too had only recently survived his own loss, the death of his young wife, novelist Margaret Latimer, in childbirth. His suffering opened on to her own.

For the first week, O'Keeffe kept to herself while Toomer spent his days working on a new novel. The house was shuttered against the winter, and O'Keeffe spent much of her time in bed. Snowbound in upstate New York, one biographer writes, they "sheltered against each other."

Toomer was a follower of the Russian mystic George Gurdjieff and practiced awareness exercises that promoted balance and harmony. His presence in the farmhouse must have been calming and centering. Soon O'Keeffe emerged from her bedroom, and the two began to talk, O'Keeffe coming back "to life." They walked together, cooked, sat in front of windows glazed with ice. They no doubt shared their pain, maybe cried, even raged against the inhumanity of it all. But mostly Toomer bore witness to her sadness and offered his own.

I can see them near the frozen lake, waves held in icy laps, the shore cracked and brittle. Here is the sky she painted so often, the shed, the barn. Here are the clouds, pregnant with snow. The two of them don't speak. Any tears that fall turn to ice almost before they leave her eyes. Amid that deadness, he tells her to listen for the cracking of sap in the nearby trees. Spring is coming.

After he returned to New York, she writes to him, "You seem to have given me a strangely beautiful feeling of balance that makes the days seem very precious." She has been changed. Not because her husband is now faithful or her art now certain but because she holds both void and bone. She follows Toomer's advice, his modeling, and joins herself to the suffering in the world. He exhorts her

to "add unto yourself more and more of this human world, and give of yourself more and more to this world." He meets her in the snows of her suffering with his own dead heart but then tells her to "let them flow in you and flow from you without fear." He does not turn away, and she begins to heal.

When it looks like the Millville fire may jump the road and begin to consume houses, the firefighters set the backburn. They had thought on Wednesday that when the fire reached the top of a long ridge, it would slow, but it didn't. It breached the hill, not even pausing for breath, and flew down the other side. High winds hamper their efforts. Just over a month prior to this blaze, nineteen elite firefighters had lost their lives fighting a fire in Prescott, Arizona. The winds had suddenly changed direction and trapped the team of Hot Shots, who had taken cover in their foil-lined emergency shelters. It was the worst single loss of firefighters since the 2001 terrorist attack. That lighting-sparked fire consumed eight thousand acres before it was contained. The Millville fire is not nearly as large as the Prescott blaze, but in firefighting, as in trauma, scale is irrelevant.

Of fuel, heat, and oxygen, fuel is the easiest to control. Knowing this, the firefighters chart the possible path of the Millville fire and then start another fire at the far end of its predicted route. On Wednesday, the second fire burns toward the primary fire, devouring all the fuel.

Backfires seem a counterintuitive response to flame. But a backfire is a controlled burn, undertaken with care and deliberation and set only when the primary fire appears out of control. It is accelerated with flammables and drip torches and monitored closely. While a backburn may be controlled, there is nothing slight about it. It is a mean fire, fierce and hungry. When a backburn is set properly, the two fires move toward each other, burning and seething and taking everything in their path. The winds of the primary fire suck the backfire inward rather than allowing it to

spread outward. The two fires race toward each other, sucking, breathing, reaching, burning. There is no hesitation, no discernment. There is flame and there is heat and there is the drive to merge, one burning source with another.

On the Monday before the winter solstice, I led the women in a guided meditation. We began by imagining a ball of light in our bellies. A seed of light, I told them, but one connected to us, umbilical and held. They were, I said, in the midst of a double winter, but the promise of renewal was not far away. Days would be getting longer now, the darkness less.

Over the course of ten minutes, we enlarged the reach of that light. First it filled our bellies, then our bodies, then the room.

"Feel the light move under the door," I told them. "All the light now pushing beneath the sill."

With our eyes closed, we envisioned the light moving down the metal stairs to the floor below us, then out the door, not needing a buzzer, permission, or accompaniment. I asked them to think of this light merging with the sky, becoming one with everything and connecting us all. In that windowless room on a day with more dark than light, we awaited the spring.

At the end of the meditation, I wanted to give them all a hug. In a few days it would be Christmas, and they would spend it in jail. I knew they had made cards for one another, gifts hidden from the guards. Brianna had spent the little money she had buying each woman in her pod one piece of candy from the canteen. "For their pillows in the morning," she had said.

Moving toward the door, with its buzzer that would release me into the wintry afternoon, I didn't hug them. Last year, one of the volunteers had embraced a prisoner he hadn't seen in months. No rules forbid such contact, but the guard didn't like it. The volunteer was not chastised, but the inmate was thrown in the hole.

"I miss the sun," Brianna said, "and a brush. We're only allowed a comb."

It's not clear if O'Keeffe and Toomer were lovers. Biographers point to different details to support the argument they wish to make. Toomer and O'Keeffe spent most of their time without others around. Only they can say what happened. It is clear, though, that Toomer brought O'Keeffe out of her depression and returned her to the sun. She begins drawing again. Not long after he has left, O'Keeffe writes to him about the two kittens they have spent the past several weeks watching. "Maybe I love her too much," O'Keeffe says, referring to her Kitten Cat. "Maybe it is something in me that I *have* to spend on something alive that is beautiful to me." I read in her lines the acknowledgment that love and loss are inextricable.

A month later, having left Lake George to go to the city to see her most recent show (hung by Stieglitz), O'Keeffe writes to Toomer about how it felt to look at her own work. "—There are paintings of so many things that may be unpaintable—and still that can not be so—The feeling that a person gives me that I can not say in words comes in colors and shapes—I never told you—or anyone else—but there is a painting I made from something of you the first time you were here—" To see that painting hung, she tells him, to see all her paintings hung, makes her feel "raw and torn." Open, like a heart.

On the day the Millville fires began, a former student of mine, a favorite, hanged herself in her living room not a mile from where I live. For years she had struggled with demons. For years she had tried to remain in this world. But in the end, there weren't enough waxwings, seashores, flame. Her husband came home to find her gone.

The day I drove to her funeral, dressed in black, ash gathered in the sky. Logan lay enveloped in smoke. Everything, it seemed, was burning.

Even though I knew I could not have saved her, I also knew I had

failed her. When her suicide threats on Facebook became too much, I did not call her. I unfriended her instead. When she shook in her skin as she described her failures, I did not share my own. I never set the backburn, never lit the match.

☙

Hanuman, the monkey god, is the god of compassion. As a young monkey, he saw the sun and thought it a mango. He leapt for the yellow light, but Indra, worried he might take down the sun, threw one of his lightning bolts at the monkey boy. Hanuman fell to the ground and cracked his skull.

"The god of compassion comes to us broken," Hope concluded. "Something for us to think about as we practice."

My mother and I had joined Hope and ten other people on a yoga retreat in Mexico, two years after my student's suicide. The morning Hope told us the story of Hanuman, we were gathered in a yoga *shala* high above the coast, the sound of crashing surf arriving like a memory. "But that isn't the most important Hanuman story," Hope continued. "It only sets the stage." She asked us to move into another pose and then continued.

Ram and Sita were married, but Sita was stolen by the demon Ravana and taken to the island of Sri Lanka. Ram sought the help of Hanuman in securing her return. Because Hanuman loved Ram dearly, Hanuman used his long monkey legs to leap the ocean and bring Sita home. In gratitude, Ram gave Hanuman a beautiful jeweled bracelet, but the silly monkey ate the gems.

"Have you no respect?" Ram asked him. "Have you no love?"

Hanuman looked up at Ram, broken jewels at his feet, and cut open his chest. On every vein of his heart was inscribed "Sita Ram."

"We are," Hope concluded, "every figure in Hindu mythology. We are the one who can leap and the one who throws lightning. We are the one who inscribes our love upon our flesh and the one who questions its limits. We are the remover of obstacles and the obstacles themselves."

Some trees require fire to reproduce. Lodgepole pines, sequoias, and jack pines, as well as species of cypress and spruce, are all serotinous trees, meaning their seeds remain dormant, cocooned, inside a canopy of tough cones for years. Only heat can open these resin-sealed cones and release the seeds. A tree may wait for decades for the necessary fire to reproduce. More incredibly, the seeds from serotinous cones grow only in ashes. They need a bed of devastation. Birth and destruction are ecologically joined. Life comes out of flame.

On Easter Sunday this past year, I attended mass at the Cathedral Basilica of Saint Francis of Assisi in Santa Fe. I was in New Mexico on a fellowship at the Georgia O'Keeffe Research Center and was spending the month of April in the city by myself while Michael and the boys finished school. I hadn't planned on going to church. I couldn't name the last time I had been to an actual service, and it had been thirty years since the masses I had attended in elementary school. There, as one of the only protestants in a Catholic school, I spent most of my time sitting on the pews while my classmates took communion or went to confession. But the basilica was the oldest parish in the United States and dated to 1610. Its rose windows and Corinthian columns suggested sacred and vaulted space, experienced best, I thought, on a day like Easter Sunday. So I went.

I arrived early, but the pews were already filling. Music played from an unseen organ, and candles lit the church. Light poured through stained-glass windows, while ushers encouraged people to move toward the center. The ceiling rose above me, painted in white and gold, and statues watched over the alcoves along the sides. I took a seat on a tiny pew without a kneeler and watched others arrive in their Easter outfits. Hats and gloves mixed with blue jeans. Children carried chocolate bunnies and jelly beans in their hands.

The service began, and I followed along in my bulletin. The words

of my childhood returned to me. The Creed and the Lord's Prayer rose up from some deeply inscribed part of my past. All around me, images of Christ adorned the walls. One of the sacred heart, with Jesus pointing to his open chest, where his heart beat and bled. The Stations of the Cross lined both sides of the basilica. In each painting, Jesus wore a halo of light, a perfect circle around his head, the seventh chakra.

During the call and response, a father and daughter sang to us: "This is the day that the Lord has made. Let us rejoice and be glad in it." We repeated the lines back. Only two days earlier, I had gone to a kirtan gathering near my apartment. On the floor of the living room, the chanter had sung, "Hare Rama, Hare Rama, Rama, Rama, Hare, Hare." And we had chanted the words back to her. We had sat in a circle in front of an altar, adorned with flowers, candles, and gold. Now I sat as if inside the altar, surrounded by incense, color, and light. It's the same, I thought. The songs, the candles, all these attempts to celebrate in stone, glass, and jewel. We were all honoring the presence of something we could not name.

"Love Each Other Constantly": the words painted over the doors as you exit the basilica. Not because you will win the kingdom of God or save your marriage or prevent the pain from coming, but because love is the practice, the prayer, the Jetway. After all, just look at the sky.

Perfectly Fantastic

ON FEBRUARY 10, 1939, Georgia O'Keeffe debarked from the SS *Lurline*, a luxury cruise ship built by Matson, on the island of Oahu. Crossing the Pacific had taken nine days, during which moon and sea had kept her company. When she arrived, she was met with flower leis and air so soft that it felt like a kiss. "Here I am," she wrote to her husband, as if she couldn't believe how far she had traveled.

When O'Keeffe made her decision to go to Hawaii, she was at a crossroads of sorts in her artistic career. By the late 1930s, the artist was firmly established as one of the most important painters in America. In 1928 six of her paintings had sold for $25,000, the highest amount ever paid to a living American artist. In the intervening decade, she had discovered the New Mexico desert, her most important source of inspiration. She had also reinvented herself by painting the bones she found on the desert floor. At the same time, amid all this success and self-realization, Stieglitz had begun his affair with Dorothy Norman. In addition, recent reviews of her work had been scathing. Typically O'Keeffe ignored what reviewers said. She trusted her own sense of a painting's value. But these reviews were especially brutal, suggesting that her bones and flowers had become formulaic, that she lacked taste, that her art resembled "mass production."

So when the Dole Pineapple Company approached O'Keeffe in the summer of 1938 and asked her to be its guest on the islands in exchange for two paintings that would be part of a national advertising campaign, O'Keeffe took the commission and packed her bags. She had received brochures of the islands—the flowers, the trees, the sea—and one can only imagine that those strange colors and shapes suggested a new kind of faraway, a fresh start.

O'Keeffe's time in Hawaii is the stuff of legend. She spent the first four weeks on the island of Oahu. During that time, the "Pineapples," the men from Dole who shepherded her from one place to another, "dumb" men with no taste, took her to the pineapple fields on the north shore of the island. O'Keeffe was mesmerized by the growing fruit, "all sharp and silvery," and the jagged mountains rising nearby. She asked the Pineapples if she could live near the fields with the workers and paint outdoors. Aghast that she would even suggest such a thing, the Pineapples refused her request. In apparent spite, O'Keeffe didn't paint a single pineapple while she was on the islands. Instead she sent Dole a painting of a papaya tree. The papaya industry was Dole's direct competition, a fact O'Keeffe undoubtedly knew. After she returned to New York, Dole had a pineapple sent express to her apartment in Manhattan in the hopes that she might reconsider the beauty of its product. O'Keeffe relented and sent a painting entitled *Pineapple Bud*, which was then used to sell juice for years.

What is so interesting about O'Keeffe's time on the islands, though, is not her disdain for Dole or her fierce independence but rather how O'Keeffe responded to a place that was so foreign and strange to her, how she brought the otherness of the islands within herself and reinterpreted her surroundings. O'Keeffe, maybe more than any other modern American painter, was influenced deeply by place. In fact, her entire body of work can be considered a call to the viewer to really take the time to look—at a flower, a sky, the shade cast by a window. Her frustrations at the inattentiveness of those around her can be seen in her autobiography where she writes, "Nobody sees a flower—really—it is so small—we haven't time—and to see takes time . . . so I said to myself—I'll paint what I see—what the flower is to me but I'll paint it big and they will be surprised

into taking the time to look at it—I will make even busy New York-
ers take the time to see what I see of flowers."

Time and attention. It's what her paintings arise from and what
they ask of us.

To be able to reveal a thing's essence, its flowerness or boneness,
so that she might arrest the viewer and cause him to stop and take
notice, required intimacy with her subject. In her autobiography,
O'Keeffe writes that she has "a single track mind. I work on an idea
for a long time. It's like getting acquainted with a person, and I don't
get acquainted easily." To understand the essence of a thing, whether
a mountain or a flower, she knew that she had to let the subject "get
under [her] skin." Which is why she famously claimed that she
owned the Cerro Pedernal, the narrow mesa that appears in so
many of her New Mexico landscapes. God told her she could have
it, she said, as long as she painted it enough. When she gave a subject
her complete attention, it became a part of her. She owned it, not
because she paid for it with money but because she paid for it with
attention. She understood it like no other.

So what happens when an artist with that kind of attentiveness
to the natural world arrives on the most geographically remote
piece of land on the globe? What happens when a painter who
requires long stretches of time in which to work finds herself in an
alien landscape for just over two months? And, maybe more impor-
tantly, what can we learn about paying attention from O'Keeffe's
struggle to integrate a new landscape into her own personal vision?

During her nine-week visit, O'Keeffe wrote close to twenty letters
to Stieglitz. In their lines, we can see her mind at work, retrace her
footsteps, and follow her gaze. Her letters reveal a journey that is at
once unsurprising and breathtaking. In her missives from the far-
away, the painter struggles to tether the dreamlike islands, to hem
them into the familiar. At the same time, it is their very impossibil-
ity that challenges and delights her.

The tension that runs through these letters—between getting it
and not getting it simultaneously—is reproduced, less clearly, in her
paintings. The twenty paintings she made from her time in Hawaii
were exhibited in *An American Place* in February of 1940. At the
time, the exhibit was hailed a success. One critic said of the works,

"This collection all testify to Miss O'Keeffe's ability to make herself at home anywhere." Yet O'Keeffe rarely exhibited the Hawaii paintings again and doesn't refer to her time on the islands in her autobiography at all. One of her biographers, Laurie Lisle, suggests that the brevity of her stay didn't give her the time to digest "the overpowering stimuli of Hawaii." The paintings, Lisle says, were not up to her usual standards. It seems they both captured and failed.

What her time in the islands gives us, though, is a glimpse into how an artist begins the process of being placed, and we see this most clearly in the letters where, in her own words, she documents how she internalizes the islands, how she makes them her own. Because O'Keeffe's visit was relatively brief, because Hawaii is so clearly foreign and overwhelming, and because the artist is such a keen observer of landscapes, these letters provide an unusual and startling look at an artist's struggle to engage a landscape. Nine weeks was enough time for O'Keeffe to understand parts of the islands. And she understood just when and how she got it right.

When O'Keeffe arrives in Honolulu Harbor in early February, she debarks a celebrity. Her reputation was firmly established by 1939, and the wealthiest families on the island—Castles, Cooks, Richards, Judds—form a line to entertain her, while photographers jockey for her picture. The first four weeks on Oahu, she is rarely left alone. Wined and dined every day, driven all over the island, O'Keeffe barely has time to catch her breath.

Her first letter home to Stieglitz, sent February 12, is twelve pages long and brims with enthusiasm about her arrival. Not uncharacteristically, the first thing she notes is the landscape around her: "The shade is sort of thick and light at the same time—the sun pale—a long dreamy blue part of a mountain rising up out of the ocean to the right and on the other side of the house a near mountain rises up so abruptly it is startling—it has a look like a sort of mossy rock—palm trees—other trees—flowery things—many birds."

O'Keeffe is standing on the lawn of Atherton Richards at the base of Diamond Head. She has not even had time to change her clothes from the boat. O'Keeffe begins her first letter home while looking at

the ocean, the smell of food wafting down from the house. She cannot wait to write. This very first moment of capturing the islands is significant. She does not know the names of what grows around her—"other trees," "flowery things"—but they still receive first attention in her letter. In characteristic fashion, her impressions tumble madly over one another, not even stopped by "proper" punctuation. She is enthralled with her surroundings.

Then she moves on to describe the flower leis she had received when she was met on the boat—"flowers strung together like wonderful wrought iron work"—and how she has poked about the gardens looking "at the things that grow." Most of it is impossible for her to believe, the colors and shapes of the flowers in particular. Nothing seems real. But such otherworldliness doesn't slow O'Keeffe; instead she writes, "I must get painting soon." She wants to get these unbelievable forms on the canvas, capture them. At the same time, even amid all this energy and excitement, there is already a creeping note of concern. "I hope I can put it into forms as well as enthusiasm." She notes, even in this first letter, that she might not be able to convey the overwhelming foreignness of the islands.

What is perhaps most interesting about this first letter is what it does not contain: people. The majority of her page space is given to describing the air—"soft" and "strange"—the flowers—"sweet smelling" and "impossible"—the mountains—"queer" and "wrinkled"—rather than the people who are hosting her. A tea given in her honor is "nice as such things go," but her passion and her page space is focused entirely on the wondrous world she finds herself in. The pitch and fever of her surroundings don't abate for several letters. Each day, it seems, she sees something more wondrous and more impossible to believe.

Even though she is given very little time to paint in those first two weeks—every day she is taken somewhere new on the island, often to another summerhouse, where she eats and wanders the gardens—she writes many times that she intends to paint and that she will begin with the unbelievable flowers. At every function, someone hands her another flower—a gardenia, a pink camellia, bird of paradise, antherium, calla lilies, red ginger—and after each outing she arrives home with "queer scraps of flowers" in her hands. They are

all "perfectly fantastic" and "unbelievable," and she can't wait to paint them. But to do that, she realizes, she must slow down. She must, she writes to her husband, "be still." Part of her inability to sit and be silent has to do with her own excitement at being in Hawaii, she admits, but part of it comes from the constant traveling she is being asked to do. About a week into her trip, she writes to Stieglitz that she is "going to stop going to places where there are so many people now and see what I can do with some of things I have collected." But that doesn't happen. The few days, or really parts of days, that she takes for herself to paint end in frustration. She writes, after half a day of work on a flower painting, that it was a "struggle." She begins again, with another flower, but doesn't have much better luck.

Theresa Papanikolas, the curator for western and American art at the Honolulu Art Museum, says that it makes sense that O'Keeffe begins with flowers in Hawaii. After all, both because she is Georgia O'Keeffe and because flowers are customary greetings in the islands, people are handing her flowers right and left. One of her new acquaintances even brings her a flower book to make identification easier. Additionally, the tropical flowers that grow in Hawaii are incredibly unusual, often looking plastic and artificial because of their brightness and their hardy blooms. More importantly, Papanikolas says, flowers were familiar to O'Keeffe. She had become famous for her flower paintings. She knew flowers. She had long been taken by their forms and "carries over" that passion to her work in Hawaii. Flowers, then, give O'Keeffe a doorway into the unusual and overwhelming landscape of Hawaii. They give her a place to stand, even when standing on ground that looks nothing like the ground she has known.

Indeed, one flower that she paints, the belladonna, is so familiar to her, looks so similar to the jimsonweed that grows in her yard in New Mexico, that in 1976 she confuses the two paintings—titling the belladonna done in Hawaii *Two Jimsonweed*, a mistake that has remained. Jennifer Saville, curator at the Honolulu Art Academy during the 1990 exhibition of O'Keeffe's Hawaii paintings, argues that O'Keeffe's Hawaii flowers are really a continuation of the flower work she had been doing. For example, she suggests, the belladonna painting is really an extension of a series that O'Keeffe began with

jimsonweed a few years prior, a refinement of the composition. What is more compelling here though is the fact that flowers provide the gateway into the unfamiliar. She takes what she knows and begins to make connections with what she doesn't know. In the same way that a child learns language, O'Keeffe scaffolds any new understanding of place to a previous touchstone. In that way, it is not surprising that the majority of the twenty paintings from Hawaii are of blooms that grow there.

By February 23, the tension she is feeling becomes palpable in her letters. The people, never her favorite subject, have become "a waste of time." At one party, she notes, she met a nice woman but "the others—oh dear!" And then, a few lines later, when forced to watch another round of Hawaiian dancing and singing: "and again I say oh dear!" Her frustration at not being able to work for long stretches of time is clear, and she tells Stieglitz, "It is difficult here—sorting— what to do and what not to do." She doesn't want to offend anyone, but she is at her breaking point with the constant socializing. It's the first letter in which she sounds homesick. She ends by writing, "I wish I could see you tonight—you seem a long way off—a really long way off—and the wind in the palm trees doesn't make you seem any nearer." The palms around her remind her in their clack and rattle that she is somewhere foreign, somewhere unfamiliar, and that alienness no longer excites but exhausts and depresses.

O'Keeffe still engages with her surroundings for the remainder of February, and ecstatic passages on the landscape abound. The "handsome" pineapple fields, the "wrinkled" mountains, more unbelievable flowers—the coconut flower a "sort of glory of old ivory." But underneath her extolling is the steady beat of frustration that she cannot get this world onto the canvas. More specifically, she is beginning to realize that her subject is overwhelming her, that she doesn't have a grasp on it. In a key moment she writes, "Many things are so beautiful that they don't seem real. My idea of the world— nature—things that grow—the fantastic things mountains can do has not been beautiful enough." She had no idea. Earlier, when met with the unbelievability of the Hawaiian islands, she responded by saying that she wanted to get painting, as if her brush could bring the unfamiliar into the known, domesticate the tropical; as if she,

the artist, had the power, was used to having the power to tame her surroundings. After all, she owns a mountain. But now, she is less sure of her ability. This landscape seems too big, too different, too overwhelming. And her paintings are "dull" to her. She confesses, "Considering what I've seen the paintings aren't much—such deeply wrinkled mountain sides with such high waterfalls could be seen through breaks in the trees across the valley—it is really a beautiful world." One has the feeling that she is humbled by the beauty before her, content to not capture it but to only have experienced it. There is a note of surrender at the end of this letter: "I'm going to drive somewhere—I don't know where—"

She rides that final dash to Hana, Maui, a tiny town that is difficult to access on the third largest of the Hawaiian Islands. In this remote outpost, on a sugar plantation forty miles from anywhere, O'Keeffe regains her stride. She realizes that she has found her way back to herself before she even lands on the island. In her first postcard from Maui, when she has just arrived on March 10, she writes, "This seems to be the best yet. . . . I will be off in the far away." The "far away" signals a place untrammeled and unknown, a dreamlike space, and the inspiration for her art. It is precious and powerful and rare. In Maui she finds it.

She also finds time. Long days to tramp about the coast, often with only Patricia Jennings, the twelve-year-old daughter of the plantation manager, as her guide. She is given a car, a station wagon, and the freedom a vehicle affords. And she paints, every day, all day. In the valley, at the shore, she takes her canvases with her, paints, as she does in New Mexico, in the open air. Now when she writes home, she still notes how "like a dream" it all is, but there is a new confidence in how she meets her surroundings. The mountains are no longer just wrinkled, the sides steep. She writes, "The foliage changes—sometimes green—sometimes cane—sometimes bamboo—in some places great spaces of very steep high cliff like hill sides covered with small ferns and many of the tree ferns standing out sort of singly." She names what she sees: bamboo, fern, cane. There is variety, texture. The beauty no longer seems to overwhelm her. Instead she meets it. There is still some concern about whether she can match it on her canvas—"I don't know whether I can or

not"—but she knows that she must slow down and look. "I feel that my tempo must definitely change," she writes in a letter on March 13, "to put down anything of what is here."

Not just time, but the time to pay attention.

What results are paintings that excite her, that meet her expectations of color and form and come close to capturing the beauty that weeks before had threatened to send her home defeated. In Hana she paints two pictures of lava against the sea, the larger of which she thinks is "really quite good." And she begins several paintings of the Iao Valley, a lush valley that is accessible only through a harrowing ride up a twisting mountain road. The land, the sugarcane in particular, she writes, has gotten under her skin. Such a sentiment is no throwaway line for O'Keeffe. She is getting closer and she knows it. She feels it in her body.

Not only can she name what surrounds her, but she can engage it physically. Browned by the sun, she writes her husband that she is "getting sure on [her] feet on the rocks" and that she is no longer afraid of falling. She clambers over lava fields barefooted and wears Japanese sandals, facts that "surprise" and delight her.

So it should be of no surprise to us that on March 23, when she drives up Mount Haleakala, the ten-thousand-foot volcano that dominates Maui, she writes Stieglitz that the volcano "floats out there in the sky like a dream when I came out of my green valley." My green valley. The Iao Valley. The landscape she has been painting and repainting for days. My green valley. The same language appears again on March 25: "With my station wagon from the sugar mill and my green valley lined with sheerly steep mountains I've had a lovely time." In one letter she underlines the *my* of "my valley," in case anyone doubts what she claims. She gives the natural world her attention, and she comes to own it, to bring it inside her. Unsurprisingly, the three paintings of the Iao Valley, a series, are considered the best of her Hawaii paintings. Their color, an impossible green, leaps from the wall, seizes the viewer, telling you less about what the valley looks like and more of how it *feels* to look, to really look. You don't see the paintings; you feel them. Deep into the folds we travel, into the deep Vs, to the point where things begin, and then we follow the cut of waterfall down, like we follow the ribbon

of road or the length of stem in other O'Keeffes, into ourselves. They are not just valleys. They are O'Keeffe valleys.

On March 31 she writes Stieglitz to say that she is extending her visit on the islands. She wants "more time to work." More significantly, she writes, "I just begin to be clear though about it all to feel that I have something to say about it." Her lava paintings and valley paintings please her, but she hasn't yet captured "the kind of color I have in mind." She begins a new painting of a flower that quickly becomes "my flower." Of this flower, she says, it is "even rare here—but it is like something I feel here—The country is very paintable but I don't get hold of a new thing so quickly—it doesn't happen in a minute." So she stays longer, painting all day, every day. Sometimes she is "disgusted" with effort, but at other times the results are "pretty good." So that early in April the flower she is painting, a cup of silver, is "lovely"—as is, she finally admits, her painting.

On April 9 she decides she is ready to go home. It's a sudden decision, at least in how she describes it to Stieglitz—"I just suddenly seemed to think it time to go so I'll be going"—and we get the sense that she has done all that she can do. In the letter right before this one, she writes that Hawaii seems like a place where few stay and most pass through. She is one of those passing through, and she has seen all that she can see, captured all that she can capture. The following day, on April 10, knowing that her time on the islands is quickly coming to an end, she writes to Stieglitz about a conversation with a Japanese driver who was taking her to Parker Ranch on the Big Island. They had spent most of the day together, she and the driver, and much of the day in the car. The Big Island is aptly named. To get from one side to the other seems to take forever when one is more used to the width of an island like Oahu. She recounts to Stieglitz that, at the end of the day, her driver said to her, "You make me see things I never saw before—I wonder if they will be there tomorrow—usually I only look at the road."

O'Keeffe may be only passing through the islands, she may have failed to achieve the kind of intimacy we experience in her New Mexico landscapes, but she has marked the landscape, with her brush and with her way of seeing. In one day, she has shown a

longtime resident how much has gone unnoticed in the landscape he drives through every day. And what she reveals to him is the dream of the land, the unknown, the heart beating beneath the skin of the earth, something precious and rare and fragile, not unlike the flowers she preserves on her canvases. There can be no doubt that O'Keeffe finds a way into the Hawaiian Islands. She doesn't simply reflect the landscape back to the viewer; she alters through her vision. And she is able to make us see, really see, the flowers, the skies, the valleys of Hawaii, because she first takes the time to look. Her ability to place herself, make herself at home, in an alien land-scape has nothing to do with how long or short she stays in a place but rather with how fully she can give her attention to it.

Her Hawaii paintings may not be her best work, and her time in Hawaii may not, ultimately, have been one of the most significant periods in her life. What we have though, in these paintings and in her letters, is the story of how we come to know—a place, a flower, a self. In that way Georgia O'Keeffe's time in Hawaii, like the blooms that grow there, is perfectly fantastic.

Spiral

> I took my chances on a perilous path, along which
> my steps zigzagged, resembling a spiral lightning bolt.
>
> —*Robert Smithson*

THE MORNING WE LEAVE for *Spiral Jetty*, the sun shines for the first time in more than a week. When Michael and I pile into our pickup truck, along with our lunch, binoculars, camera, and journals, I can't believe the clarity of the light—that the nearby mountains can possibly be this green, the sky this blue. It is as though I have been asleep for years, only to be reborn into a world that is unacquainted with the color gray or edges that are anything but crisp. And perhaps I have. The past winter was the hardest in northern Utah's Cache Valley in eight years, bringing day upon day of snowfall, so much that we no longer had any place to pile the shoveled snow and simply gave up. Snow continued into May, swamping the tiny mountain fawn lilies that dared to bare their heads. In addition, we have two young boys, ages four and two. In four years, I have hardly slept through the night, having grown used to one or the other hauling me from the sea bottom of sleep to adjust blankets, scare away monsters, assure them that I am here.

I blink in the sun.

Yellow mule's ears grow in small fields along the sides of the Bear River Range, raucous bursts against a brilliant green. They remind me of the first time we took Aidan hiking. He was six weeks old, and the sunflowers were in full bloom, banging their heavy heads against our legs as we walked the trail. I held Aidan against my body in a front pack and worried that I would stumble, swing him into a tree. Turns out I should have been worrying about hail, the kind that arrives unannounced in the late spring and pelts your body. When the storm hit, both shelter and car were far away. Michael bushwhacked a path straight up the side of the mountain, into a thicket of small firs. I followed, wondering what kind of mother I was to bring a newborn into the wild.

Within minutes, though, I was nursing Aidan under a towering fir near a fire Michael had built out of nothing while the hail grew in piles like stones. We huddled in a refuge ringed by sunflowers; the warmth of the fire matched the warmth of my son's skin. Every spring when the mule's ears bloom, their bodies bending toward the sun, I think of that first hike, the hailstorm, the shelter, and the emerging knowledge that we were responsible for a being who could not even lift his head.

Georgia O'Keeffe first sees the hills she will come to call the Black Place in 1936. Lying over a hundred miles from Ghost Ranch along the rutted roads of the Bisti Badlands, the hills were nearly inaccessible. It took four hours to drive from Ghost Ranch to her preferred site, hours she often drove in the middle of the night so that she could arrive with the sun. She would stay for several days, camping with her friend Maria Chabot. The two would sleep on cots in a canvas tent and cook over an open flame. Each day O'Keeffe would climb or paint the sandstone and shale formations, slopes shaped by eons of wind and water.

In her autobiography, she describes the mountains as a "mile of elephants—grey hills about the same size with almost white sand at their feet." Given the desolation and emptiness of the landscape, most people drive right past the scene without a second glance. But O'Keeffe returned again and again, making seven trips between 1941 and 1944 alone. Within a decade, she would produce

fourteen paintings of the same hills, the same crevice, the same siren slopes.

In the first of those paintings, finished in 1936, the hills are not black but gray, soft and muted. No vegetation dots the hillsides. Except for some sage in the foreground, little grows. Emptied of all that we would typically value, the badlands bake beneath the sun, burned to their most elemental of forms. O'Keeffe has cropped the view, moved close to the hills so that they rise, magnified against the little bit of sky allowed to remain. In a familiar move, whether working with flowers or bones, she intensifies the shape by bringing it closer to us. The Black Place arrives on her canvas in 1936 emphatic but soft. In the folds of the hills, land like skin, released from bone and muscle, you see a body, worn but strong. Down the center runs a tiny riverbed, thin, dry, a course that courses no more.

Robert Smithson came west in the late 1960s in search of the kind of contrast I see on the slopes as we drive, winter holding on, spring bursting forth, beauty in the dissonance. He was young, in his late twenties, ready for something new. Like many of the artists of that time influenced by Duchamp and other surrealists, he sought art outside the gallery, outside the establishment. He sought space. Born in New Jersey, trained as a painter, he quickly moved to sculpture, the form that would eventually allow him to become one of the most important artists of the late twentieth century. His masterpiece: *Spiral Jetty*, an enormous earthwork that swirls into the northern reaches of Great Salt Lake, fifteen hundred feet of black basalt spiraling inward and broad enough to walk on. A deliberately remote work, *Spiral Jetty* waits at the end of a fifteen-mile dirt road, requiring a vehicle with four-wheel drive and high clearance. More than thirty miles from food or gas. No cell phone service. No houses. No freshwater. Only the sun-stroked landscape of the West Desert, a place so vast and uninhabited that the military uses it for bomb runs and munitions tests.

Michael and I descend into the desert in a truck, strangely quiet without the boys. Several times I reach for the radio but stop myself. The rare traces of habitation—an occasional ranch shed, an

abandoned rock quarry, gutted tractors that oxidize in the air—echo the emptiness in the truck. The last time I drove to *Spiral Jetty*, I was six weeks pregnant with Aidan. Today I share my body with no one.

Michael sits beside me, his long arm resting on the window. Every now and then he points out a bird or flower and jots the name down in a tiny notebook. In those moments, I catch sight of our former selves, the ones who could spend an entire evening following a heron in our canoe. The memory is vague though, two wine-drunk lovers at dusk on the Huron River, the sound made by the prehistoric wings of the great blue as he swoops above our head. It is hard for me to recall how they spent their days.

Past the town of Corinne, we travel through a marsh brimming with red-winged blackbirds and tiny marsh wrens, ibises strung out like black pearls across the sky. I listen for blackbirds, watch for flash of red on wing. When I open my window to hear, I smell the sea.

An ancient sea helped shape the Black Place, salt water riving rock. Also an ancient fire that burned for centuries, ignited by volcanic eruption and fed by coal deposits laid when dinosaurs roamed. O'Keeffe mentions none of the geologic forces that have shaped the hills when she writes her husband. The discovery of flame beneath stone will come later.

On November 7, 1941, she sends Stieglitz a letter letting him know that she has returned from one camping trip to the Black Place and would like to set out on another immediately.

> —I painted two days—have a good one—and I want to go back there again tomorrow—by starting in the star light before dawn I would get there in time for a good days work—That is what I will do if your wire says you are alright
> Oh don't think me crazy—I am not

Four hours there, four hours back, wind and rain and hail and a cot for sleeping, yet she wants to return immediately. That same fall she writes to Caroline Fesler, president of the Art Association for the

Indianapolis Museum of Art, that the hills have become "a place that I love."

Stieglitz wires O'Keeffe, encouraging her to extend her time in New Mexico. Within hours she and Chabot are back in her station wagon headed for the hills. "Good Morning from the Black Place," she writes to Stieglitz the following morning, November 10. She continues, "—here for two nights—fine and warm in bed—sunny days—I have another painting well on the way . . . wish you could see this place—I've climbed a lot this morning."

Photographs taken by Chabot several years later will document both their camping and their climbing. A tiny canvas tent set amid an ocean of nothingness, ropes to hold the corners down. Meals eaten on chairs made for children that stand not ten inches from the ground. A table set with syrup, dishes, and fruit. The Black Place looms behind them, rounded, lumbering, patient. When they move into the hills and climb the rubble-strewn slopes to photograph the surroundings, all sense of scale vanishes. Without a tent for comparison, they could be scaling the moon.

Whenever Aidan and Kellen climb my legs, I pick them up. Holding their increasingly heavy bodies against mine, I can feel their rabbit hearts beat madly, smell the sweat in their hair, taste the salt on their skin. I tell myself that someday, very soon, I will arrive at the day when I pick them up for the last time. I won't know the day. It will feel like every other day, filled with the small battles and joys that mark the boundaries of child rearing. It won't happen for a few years, but it will happen. There will come the moment when I no longer carry them.

I cannot remember the last time my father picked me up, but I do know when he last held me. I have a picture, taken when I was eighteen, of me sitting in front of him, watching television. We are at my grandmother's house, just after she has died. I have been at college for only a month before I am called to her funeral. In the picture I sit between his legs, my back pulled against his body, his head resting on mine, apparently asleep. If my mother hadn't taken the picture, hadn't found it amusing that my father was asleep on my head, I would not be able to name this moment. Tectonic shifts happen in

our lives all the time, but we rarely document even these, much less the smaller increments of change. So much passes unmarked. Sometime within the past year, I nursed Kellen for the last time. I can't tell you the day. It has slipped quietly and without notice into my past.

Robert Smithson wanted to document the passage of time. He loved time, deep time, the kind of time it took for a river to form a canyon, for rocks to turn to sand. The only way to visualize time, he thought, was through entropy, by watching things change, decay. His earthworks, *Spiral Jetty* in particular, became geologic clocks, places to witness evolution at work.

Which is why he sought the salt in the Great Salt Lake and insisted that salt crystals be included in the list of materials that comprise *Spiral Jetty*, along with rock, earth, and water. Salt would be one of the primary agents of evolution, the most readily available means to index the passage of time. Smithson knew what would happen to the rocks he placed in the water, knew the salt would accumulate in thick layers in a matter of years. Along with the wind and the waves, the replication of the salt crystals ensures that *Spiral* Jetty is constantly in motion, even when the movement is toward diminishment.

At the Golden Spike Historic Site, a monument thirty miles into the desert dedicated to the joining of the Union Pacific and Central Pacific railroads, our tires leave pavement and we turn onto dirt. The directions to *Spiral Jetty* ask drivers to count cattle guards and rely on weather-beaten barns instead of signs to mark the way. Most people who know *Spiral Jetty* have seen it only in photographs taken from planes flying high above the lake. Visitors are rare. You have to want to get there.

We drive the road, looking for fences and cattle guards, boulders that might leave us high centered, stranded in the acres of brush and sage. Hills rest in the distance to our left, and the valley bottom stretches out in all directions, dotted with wiry scrub brush, the occasional cattle chute, an old tennis shoe. At cattle guard no. 2, halfway into the fifteen miles, a golden eagle sits atop the wooden post not ten feet from our car. We stop.

With an average wingspan of seven feet and a body length about half that, golden eagles dominate a genus of birds brimming with giants. You don't realize just how large they are though until you see one perched before you. The eagle leans forward, ready to sweep down or fly away, enormous, with rich brown feathers, a golden crown, and a hooked beak the size of my fist. The dust from the truck settles on the road like a blanket behind us. We are considered by the guardian of this bowl of desert: two people in a red truck who have never kettled the currents of the wind. Seconds later, the eagle lifts off and soars into the sky, circling around for a second look before flying away.

Michael gets out of the truck to stretch his legs and stand in the place where the eagle just stood. I join him and immediately feel the heft of the salt air, shade my eyes against the reflection of the sun off salt that piles in drifts in the distance. Crickets buzz and chirp, grasshoppers fly amid our legs, and the eagle turns into a tiny dot on the horizon.

O'Keeffe cannot stay away from the Black Place. She returns again and again, in the heat, in the cold. Two paintings in 1936, another in 1941, two more in 1942, and then another in 1943. Sometimes she paints from memory back in New York. The hills stalk her across the continent. Less and less sky appears as she moves closer to that riverbed, which has now become a crevice, a wide V in the center of the work. By 1944 no sky will remain at all, the field of vision greatly diminished. At that point she takes us into the rock itself.

In 1943 she writes once more to Fesler. Her most recent version of the Black Place, she tells her, "was painted in summer when the sun seems to burn the color out of everything." And indeed, her 1943 paintings of the hills are bleached and almost without definition, as if the form hibernates under the sun. Patience, the painting suggests. Both landscape and artist remain in a heat-baked cocoon; something is trying to be found.

"Everything must be done again," she tells Stieglitz in the summer of 1943. Once is not enough. What she sees is not changing, not literally. The hills have risen from the floor of the Bisti Badlands for eons. Light plays on their faces. Snow skiffs their tops, but the

mountain shapes do not change. What changes is O'Keeffe. She has, she has long understood, "dozens of selves." She is circling about her subject, wheeling the air like an eagle. Each painting in the series documents her changing self in relation to the constancy of earth.

Once Smithson had leased the land and secured permission from the state, he spent six days in April of 1970 moving earth. He hired a local contractor to excavate the nearby mountains, relocating sixty-five hundred tons of black basalt into the lake. Then he placed the rocks, one by one, to create a jetty fifteen feet across, shaped in three coils of mud, salt crystals, rock, and water.

You can see his work from space.

We step from the truck into a quiet unknown in my life, one that comes from centuries of not speaking. Then, far off, a meadowlark trills his song to the sun. At the edge, even the lake is silent, as waves dissolve into a thick sludge of salt.

We leave the truck parked and check to make sure we have everything before turning to a track that runs parallel to the shore and leads to *Spiral Jetty*. Then we look out. The water is the color of blood, the wine-dark of Homer's sea, the red of afterbirth, of algae trapped in glaciers far up in the Rockies. And set as it is against the prairies of salt that mark the highest reaches of the lake and a sky high above ringing blue, the red is made redder still.

The epigraph to Smithson's essay "Spiral Jetty" heralds the color red as "the most joyful and dreadful thing in the physical universe; it is the fiercest note, it is the highest light." The site he chose, off Rozel Point, is the saltiest part of Great Salt Lake, exceeding the 27 percent salinity in the rest of the lake. A causeway built in 1959 for the railroad effectively cut off the northern reaches of the lake from freshwater infusions. The bacteria and algae that thrive in Great Salt Lake do especially well in the northern end, turning the water to blood.

We walk the last few feet and peer over a shallow bank leading up from the lake. Smithson's earthwork spins out from the shore, the lake glistening red all around. The air is still except for the meadowlark, who continues to sing, unaware of the vortex spinning below.

Spiral Jetty is smaller than you expect but then bigger at the same time. Your sense of scale is thrown off. Smithson wanted you to wonder whether you were looking at a crack or the Grand Canyon, a rock or the earth itself.

In the fall of 1943, O'Keeffe and Chabot are caught in a storm while camping at the Black Place. Of her first morning there she writes, "Up before the sun and out early to work—such a beautiful—untouched lonely feeling place—such a fine part of what I call the Far Away." She admits that she has painted the same scene before but adds that she "wanted to do it again—and even now must do it again." An imperative marks her time there, an "intention" she will call it later in the same letter, dated October 19–20. So when the storm arrives—all wind and cloud at first—she hesitates to depart. She wants "to go further into the hills." But instead they pack up their camp and move to a more protected location. "It is," she concedes to Stieglitz, "the sort of place you do not go into unless the weather is clear."

In their new campsite, on twin cots inside the tent O'Keeffe only recently purchased, they lie awake as the storm comes down. Wind, rain, the rattling of canvas. "Everything seemed to be blowing away including us," she writes. When the tent collapses, the two women confront the storm full on and tie the tent corner to the car. In the loud and angry night, they lash themselves to whatever might not blow away. When O'Keeffe peers out at dawn: "It was as dismal as any time I've ever seen—everything grey—grey sage—grey wet sand under foot—grey hills—big gloomy looking wet clouds—a very pale cloudy moon—and still the wind." The scene is apocalyptic in its desolation.

At the end of the letter though, O'Keeffe writes that she "loved it" all. Meeting the elements, struggling against wind and rain, feeling the fury of all the world has to offer, and then fastening down what she could not afford to lose, it is no wonder that her next paintings of the Black Place are considered her best. Here, sky is gone. Here, we enter into the very crack, the very crevice, the riverbed she has been exploring for years. The Black Place is no longer hill. Now it is void, darkness, crevasse. We move inside the mountain, inside the

folds she has been studying, sketching, painting for hours and hours on end. And what we find is fire, a black-cracked bolt of lightning running through the land. The crack magnified; the crest lost. She has found fury and fold, the ordinary and the sublime, the near and the faraway.

Michael likes to tease me that the motto I live by is one I share with Queen Elizabeth I: "semper idem." Always the same. I eat the same thing for breakfast every morning, run the same route, brush my teeth the same way, prefer my coffee from Starbucks when we travel because I know it will be the same every time. My need for order and a routine comes in part from a childhood of uncertainty—a father with a temper, whose career in the military meant constant relocation and nightly dinner conversations that circulated between mutually assured destruction and nuclear attack. I thought it only a matter of time before we were annihilated. Every bowl of Cheerios is a rampart to ensure this day is the same as yesterday and the same as the day before; nothing has changed.

My children have challenged my desire for preservation in the way they refuse to remain still. I try to keep up with them by recording daily what they do or say. I know that my words root me to moments that have already slipped away, water through my fingers, wind through my hair. Even worse, that I have missed more than I have saved, that I cannot capture change.

Spiral Jetty never remains still. Smithson felt the swirling of the landscape, the "gyrating space" created by land and water, when he stood on Rozel Point, Great Salt Lake "bleeding scarlet streaks" and the sun pouring down. He writes, "The shore of the lake became the edge of the sun, a boiling curve, an explosion rising in fiery prominence. Matter collapsing into the lake mirrored in the shape of a spiral. No sense wondering about classifications and categories, there were none." Big and small, near and far became meaningless when pulled into the cyclonic spinning.

"Following the spiral steps," he writes, "we return to our origins." His sculpture was meant to be a kind of birth experience, *Jetty* buffered by the womb of Great Salt Lake, our blood containing the same

composition as "the primordial sea." And it was meant to be endless, the constant turning inward, much like the way a crystal forms, replication upon replication, no end, no beginning, no sense of time. He hoped the viewer would become overwhelmed by the dissonance of the place—the interplay between sculpture and land, the inability to distinguish the basalt in *Jetty* from the basalt in the nearby earth, to no longer be able to say for certain what was present and what was past, what existed for whom, and when.

What he couldn't anticipate was how the drought recovery would affect the earthwork. Smithson built *Spiral Jetty* in the spring of 1970, at the end of a seven-year drought. Within three years, the sculpture was covered with water and would remain submerged for most of the next thirty years. Only in 1999 would it reemerge, "clad in a glistening white armor of salt crystals." A rebirth. A new body. An evolved form. Smithson, though, would never know his art as it aged. On July 20, 1973, while viewing the site for his next earthwork, in Amarillo, Texas, his plane crashed, disintegrating his body in a fiery explosion and returning him to the land.

It's not just the ferocity of the natural world—the terror and holiness within any landscape—that pulls both O'Keeffe and her viewers into that crack. It's death itself.

In 1943 O'Keeffe writes Stieglitz at length about the Black Place. "Out where I was camping—against a grayish white sand hill with a sort of yellowish top—very irregular and creased looking—white and hard underfoot like a beach—the silvery sage stretching away for miles—a few thick scrubby fine yellowing dark green cedars—about half a mile away—both front and back the long formations of the black hills—sometimes long lines of very dark almost purple red in them."

She is giving him the Black Place in words as well as paint. The colors, the shapes, the bits of vegetation. As she has been doing for close to twenty years, she describes a world that has moved her entirely but that he will never see. "It is so unbelievable—the color—the smell—the heat of the sun on it," she writes. "I would often stand and look about and wish that you could stand there with me for just a few moments." As she had when standing on the Texas plains, or

the coast of Maine, or in a field of pineapple, she wishes his presence beside her.

But then she does something different. She brings him there— not through language, not through paint, but into the landscape itself. She writes on August 18, 1943, just after a five-day camping trip to the Black Place, "When I see the country in its silvery beauty and forbidden blackness in my memory—it is so often almost as if I see you too—your silvery hair and gray clothes and black cane— handkerchief in your hand and mouth—looking about—

—alone in it—"

O'Keeffe never painted portraits. People populate none of her landscapes, none of her cityscapes. They cannot be found amid her flowers, shells, or bones. Her landscapes often feel uninhabited. For her, people only made the country ugly. So to see her husband in the land—or to see the land as her husband—is fairly startling. And given that this realization or understanding happens at the very moment we enter the crack, it is hard not to imagine that part of what is changing for O'Keeffe across the Black Place series is the presence of Stieglitz in her life. He has been at the very center for so long, but in 1944 he is frail and dying. He has suffered several heart attacks. His writing shakes on the pages of the letters he still sends every day. He often forgets, repeats himself. He is fading.

And in fact, almost exactly two years from the date of this letter, a little more than halfway through the Black Place series, Stieglitz dies, leaving these paintings, this series as the one that documents time and passing most closely.

Feeling the sacredness of the place, we maintain the silence and step onto *Spiral Jetty*. Salt has softened the rocks, filled in the crevices. *Jetty* is growing older. The roughness of the basalt has been rounded into boulders by the water, the weather. The edges aren't as clean as they once were, the sides not as high, the contrast between the black basalt and the red lake not as stark. It is dissolving. I bend and taste the water, feel the coolness of the sea. A small sip and my mouth tightens against the bite, my instinct to chew rather than swallow. Behind us Rozel Point rises into the noon sun. We walk.

Because I am standing in a sea of crystals, everything shimmers,

tiny mirrors shine from every surface and catch my eye, like a million glinting nickels. The lake moves, bringing waves of foam into *Jetty*, a constant lapping of waves against salt-encrusted edges. *Jetty* crackles and pops, sounds I associate with being in the ocean, snorkeling amid the shush and rattle of the sea. Nothing lives in Great Salt Lake except for tiny brine shrimp, so the beat of the waves against *Spiral Jetty* becomes the heartbeat of the lake itself, again and again and again, beating constantly. That night I will hear the sound in my dreams, will think of *Jetty* under the moon, waters rising and receding, salt crystals replicating under a sky that never stands still.

Stillness and change mark the Black Place as well. The mountains are there; the mountains are eroding. Stieglitz is there; Stieglitz is dying. The cosmic and the individual, the macro and the micro. O'Keeffe writes of the landscape, "The world is so much bigger than what one can be. . . . It is so good to be out there—shaken down to ones smallness."

On June 10, 1944, Maria Chabot adds her experience of the Black Place when she writes to Stieglitz, naming the Black Place "Georgia's country." At "the very heart of the blackness," the rock strata "flow downward," she says, "one below the next. Incredible stillness." The landscape both moves and stills. O'Keeffe hikes back into the hills, away from camp to sit for hours and attend the light, the wind. She is not the same person she was yesterday, nor the same one who painted the mountains the year before. Yet she sits in folds seemingly unmarked by time in a body as familiar to her as the sun. They have arrived, Chabot writes of the Black Place, at "everything."

"A pure and perfect thing before the eye," Chabot concludes her letter, "makes us question ourselves." All that stillness and change is "why all of us are here."

Halfway to the center of the spiral, I stop. I don't want to get to the end. I stand instead in the present moment, in the stillness of the now, midspin, midday, midlife, caught between beginning and ending, birth and dying, To remain in the now is to remain outside of change. You are always only now. I sit and watch the water, listen to

the meadowlark, picture my boys at home. They are with me on *Jetty*. In fact, they are *Jetty* itself. As they grow, I witness the passage of time. The only way not to grieve that evolution is to remain in the present moment, even as the present moment spins beneath me. "One seizes the spiral," Smithson said, and then one becomes it.

Toward the end of her life, O'Keeffe returned to the Black Place with Juan Hamilton and the filmmaker Perry Miller Adato. Together they stood below the striated hills. Adato asks the almost ninety-year-old O'Keeffe, "Have you climbed?" He gestures toward the slopes behind them. O'Keeffe laughs, "Oh certainly. Wouldn't you?"

She tells Adato, "The cliffs over there. You look at it and it's almost painted for you, you think. Until you try. I tried to paint what I saw."

But O'Keeffe would have seen nothing that afternoon, aside from shadow and light. At that point in her life, she was mostly blind. Hamilton accompanies them on the walk to the Black Place because, without his arm, she would easily have fallen. Watching the film, you would not know O'Keeffe could not see her own country. She knew every feature, every slope, every angle. She knew how the light played on the cliffs at every moment of the day. Day after twelve-hour day, she sat mining the hills for their color. She had been inside.

Blindness was its own kind of death for O'Keeffe, an artist who could no longer see. But the winnowing of her sight returned her even more forcefully to the elemental shape of things. Her blindness, Christine Taylor Patten, one of O'Keeffe's assistants in her later years, tells us, "freed her into an even more simplified and matter-of-fact existence." While it is clear that O'Keeffe tried to conceal her loss of sight from most people, it is also equally clear in the way she walks the Black Place on film that the world she loved so dearly had not been lost at all. Its every line, every color, every slope had first originated inside of her.

The year after Stieglitz died, O'Keeffe completed one of only two sculptures she made in her life. With the help of artist Mary Calley, O'Keeffe produced *Abstraction*, a lyrical spiral done in a white that shimmers like salt dried under the sun. It wasn't her first spiral

form. Even her early work shows her interest in the shape. But it was her first sculpture of that form, and it arrived right when Stieglitz was exiting her life. Years later she told Patten, "If whatever I painted didn't stand up against that I knew it was wrong." The spiral, a forever circling form, inward and in touch with its past, held by the artist for a moment, revealed a "pure and perfect thing."

I Must Speak to You

IN THE SPRING OF 1959, Georgia O'Keeffe spent close to four months in Asia, much of that time in India. During the trip, she wrote a handful of letters to her sister Anita Young, describing the countries she visited and the "astonishing things" she saw. Those letters were especially important to O'Keeffe; on stationery from the Raffles Hotel in Singapore, O'Keeffe explicitly asks that they be saved: "Will you keep my letters for me and return them to me when I get home." It was as if she knew from the very beginning that the trip would matter to her deeply. Or maybe she left for Asia ready to be changed.

By the time O'Keeffe boarded the plane in the spring of 1959, she was already a world traveler. South America, Mexico, and Europe were behind her. Still, traveling to India in 1959 was no easy feat, even when part of a tour group. O'Keeffe got ready for her trip by reading about how to dress for the heat and the culture, how to prepare food and water, and how to mail letters home. She had spent years intrigued by Eastern religion. Both her Ghost Ranch and Abiquiú libraries are full of books on Eastern art, architecture, philosophy, and practices. Specific books, like Stella Kramrisch's *The Art of India*, are festooned with bits of paper marking the art she either wanted to see or did see while abroad. When she boarded the plane from Albuquerque, she was as ready as she could be to visit the other side of the planet.

Kellen warned me about the scissors. We were sitting inside the terminal at the Pune airport, waiting for Michael, who had gone in search of counter 9 to pay the overage fees for our luggage. *Overage* was already the word of the day. Minutes earlier we had been swindled by the taxi driver who had brought us to the airport in the predawn dark. He had charged us thirteen hundred rupees for the fifteen-minute ride—seven hundred rupees short of our daily living allowance. It was just six in the morning.

"The sign says no scissors," Kellen told me. He had been reading the list of items not allowed aboard the plane.

"They mean the pointy kind," I said, "the kind that can stab people. Not the kid kind."

I looked at his shorts, which were covered in the chocolate gateau he had eaten the day before. Because we were washing our clothes in the sink every night, we had encouraged the boys to wear their shorts for at least two days. At eight years old, Kellen had taken clothing conservation up a notch and was now sleeping in his clothes each night. I didn't want to know how many days he had been wearing the same pair of underwear.

"Kellen, those shorts are filthy. I thought you said you checked them this morning."

"It was dark," he said. And it had been.

We had been up since four. Because none of us had adjusted to the towering time change, an alarm proved unnecessary. We had been in India for a week by then, the first week of a three-month stay. Michael had been awarded a Fulbright to teach, study, and write in India, and we had come with him. Four in the morning is nice in India in May, cool and relatively quiet. The birds, the dogs, the occasional horn.

Michael returned from paying the overage fees, and we stood in the tenth line of the morning. We were all carrying heavy backpacks because we knew weight was an issue for checked bags. Even with straps straining at our shoulders, we had still been five kilograms over the allowance; hence the trek to counter 9.

Security proved the usual hassle, plus the addition of not knowing the procedure—women only through this metal detector, take a number along with your bin, phones in a special bin. We thought

we had made it through. We were all on the gate side of the security area. But then we saw that three of our backpacks had been held hostage.

"That can't be good," I said.

The security guard, a woman in a tight-fitting tan uniform, with hair pulled back in a bun and sari-bright lipstick, asked us which bags were ours.

"All three," we said.

She brought Kellen's over first.

"Please take the scissors out."

My heart dropped. Kellen looked up at me, panic in his eyes. I opened his purple pencil case, where he had dutifully packed his scissors the night before when I told him to get organized. I pulled out the yellow scissors with their rounded tips and showed them to the security guard.

"No scissors," she said.

Kellen collapsed into tears.

They were his yellow scissors, his favorite pair.

"I'll buy you another pair," I pleaded. "The same kind. I promise."

But he kept crying. I knew how much the scissors mattered. This was a boy who was carrying in his backpack—among other things—a red bottle top from a juice he had at Starbucks months before, an empty Lego box, several rocks, four empty packets of Trident gum, three thin green straws, and a small collection of armor he had fashioned out of paper for his stuffed animals.

I looked at the guard. "He really loves those scissors."

"No scissors."

There really wasn't much to be said.

"Be strong," Michael added, words we had been saying almost every day to the boys as we urged them through the fragrant streets and pulled them from one tuk tuk to the next in the hundred-degree heat.

The woman brought Michael's backpack next.

"Something metal in here. Please take it out."

Michael pulled out his iHome speakers; no. His iPod; no. Headphones; no.

She pointed to the bottom of his bag. It was full of Magna-Tiles.

"Not the Magna-Tiles," I said. "No way." Sentimentality was one thing, but here we were talking about a hundred-plus-dollar toy of magnetized building plates. And I couldn't fathom the hysteria we would have on our hands if we had to give those up.

"Here too," the security guard said, and she pointed to my backpack, where I was also carrying a bag full of Magna-Tiles. They were heavy, obvious content for our backpacks.

"Michael—"

"It's just money," Michael said.

You have no idea how much, I thought.

"What can we do?" he asked her.

She looked at us and then at Kellen, who was holding me at the waist and still crying. "You give them up or put them in checked baggage."

"But those bags are already gone," we said (overage fees and all).

She told us we could convert a carry-on into a checked bag and go back through the screening process again.

Our flight for Delhi left in half an hour, but there wasn't even a choice.

Michael left with his boarding pass and my backpack, which had been converted into luggage. It was full of Magna-Tiles and one pair of yellow-handled scissors.

Through the glass I could see Michael talking with the agent at the ticketing counter. I watched him send the bag through security and return to the counter for more pleading. I kept waiting for him to go to counter 9 again, but he didn't. Instead I saw him check the backpack and negotiate security for a second time.

"Did we pay?" I asked, imagining that a fifth piece of luggage would be a hefty fee. But it turned out that a man at the counter had taken pity on us. He took the backpack and charged us nothing.

"He was older," Michael said, "and he said he would slip it through."

A gift. Not unlike the streets themselves, I was learning. Dirt and grime and trash and dog mess and noise and smells and poverty that tugs at your gut and then, right at the corner, a flame tree throwing a field of red flowers across the sky, a woman offering you

bananas as bright as the sun. You can't pack for that. Nothing pre-pares you for either the dirt or the light.

O'Keeffe's first letter home from Asia begins a theme she will carry across her trip—in fact, a theme she carried across her life: the desire and the inability to fully capture the world around her. In a letter from Japan begun February 1, 1959, she starts to describe the temples and shrines, the climb up the mountains to reach them, but concludes: "They were wonderful in a way that is very difficult to explain." Later in the same letter, having visited a Zen temple with a room for meditation and a stone garden, she adds, "The good things are so good one just can't tell about them."

Though we know O'Keeffe's letters are filled with lyrical language and stunning details, we also know she just as commonly asserted that what she was seeing and experiencing was impossible to put into words. The gaps telegraph abundance rather than emptiness. For O'Keeffe to admit that she can't address her experience on the page alerts us, as readers, to the fact that she has entered the very kind of space that propelled her art. Think of the flowers in Hawaii, the coast in Maine, the wide-open spaces of Texas. O'Keeffe loved to have her world turned upside down. The plains of West Texas, a barren landscape most would avoid, inspired her because of their very emptiness. In that early letter to Stieglitz about the plains sur-rounding Canyon, she writes: "More—I want—to say—but what—" After that dash—the mark of punctuation that opens a syntactical void on the page—she continues, "I guess that space is between what they call heaven and earth—out there in what they call the night—is as much it as anything." It is the "it" found in emptiness, the inex-plicability of seeing, that she pursued on her canvases. And the approach to the "it" is often signaled in her letters by dashes, white space, and grieving the gap between experience and words.

Her frustrations with language and her proximity to the ineffable only intensify when she leaves Japan and arrives in India. Half of her time in Asia is dedicated to India, and it is clear in the number of postcards and booklets she collects and carries home that India moved her most strongly. Almost before she sets foot in the country, she understands that what she will experience there will change her.

Her second sentence posted from India reads: "It seems that as we go on more and more what I see is hard to tell about."

In many ways the grace of India eludes me most on the page. I seem to have more words to name suffering and difficulty. Joy tends to pass unmarked on the streets and in language.

The house we rented for two months in McLeod Ganj, a tiny town in northern India, two miles north of Dharamsala, sat at about five thousand feet. From its windows, we could see the Himalayas all around us. Snow-covered even in June, the mountains rose sharp and jagged into the sky. I ran into those mountains every morning.

Often, while running along a dirt road above town, I saw "my monk," one of the many Tibetan monks who walked around the Dalai Lama's temple each morning with prayer beads in hand. As always, he was dressed in his long maroon robes and yellow Adidas jacket. The yellow made me happy, as did the wide smile he gave me every time I passed him. Sometimes he ran; other times walked. Unlike the other monks I saw on the temple trail, he never held mala beads in his hand. I liked to think he was marking his mantra with cedars and pines.

We nodded every time we saw each other.

One morning on my way back into town, I found my monk sitting on a step with a friend. They were drinking narrow glasses of chai, immune to the buses and motorcycles streaming just inches from their knees.

He smiled. "Tea?" he asked. He gestured behind him, maybe to a pot or a thermos.

I did not know his name, had never even spoken to him, and yet he offered me a drink, a seat, a place on the road. More amazing still, he was the second person in a week to do so.

Days earlier a man with no legs had offered me chai one afternoon when I saw him on the street. I had stopped to give him a hug, to check on him.

"Tea for you?" he asked, pointing to the tea stall across from where he sat.

The first time I had seen the man he had been sitting on the side

of the road begging, his withered limbs gathered beneath his torso. Covered in dust, he was the color of the road. I imagined someone brought him to the same spot every day to beg for rupees. I tried not to look at him when I gave him coins.

The next time I saw him, again on my way home for running, he was not sitting on the side of the road. He was pulling his body down the mountain. The trunk of his torso drug against the dirt, his withered legs dangling after him like kite tails. He went down the mountain backward, his hands like crutches, step, drag, step, drag. On his back, he wore a faded red backpack. A used Aquafina bottle was bound to his torso with a string.

No one carried him down. No one carried him home.

I stopped and watched him move down the mountain, legs dragging, dust rising from the road with each step. Sweat dried on the back of my neck. Above me the trees swayed and monkeys swung from limb to limb. India was hard. And it was hard not just because I saw this man dragging his own body down the hill so that he could sit in the hot sun and beg privileged tourists for spare change. It was hard because when I put my hands to my chest, looked him in the eyes, and said, "Namaste," his face broke into a grin, his eyes open and bright.

India is complicated in a way that the rest of O'Keeffe's travels are not. She visits the site where the Buddha gave his first sermon in Varanasi, and she climbs to mountain stupas to share tea with Tibetan monks ("I feel I have been on top of the world"), but she also faces the crowded streets, the poverty, and the heartache. She writes, "All these places are dirty and crowded—people dressed in white that seems never to be washed." In Varanasi, she adds, "There were harrowing sights in the streets," but, she tells her sister, she just learned to not "look at it."

O'Keeffe gives no more detail about what she witnessed. She does not reveal what she did not see. I imagine she faced men without limbs and children without mothers, as well as the heartbreak that happens when the number of palms outstretched far exceeds the rupees you have to give. The press of such need, combined with a cacophony of sound, scent, and color, overwhelms. All those sights

remain unwritten but not unexpressed. Both the joy and the difficulty of India leave her outside of language, but neither leaves her entirely.

One morning in early June, we set out for our first visit to the Dalai Lama's temple. At the narrow road above our cottage, we joined the monks and pilgrims to walk the path through the deodar forest. They held meditation beads in their hands and chanted softly when we passed them. Some carried canes. Some umbrellas. The older women, worn and folded like paper bags, reached out to touch Kellen's cheeks. Above us prayer flags dressed the forest in necklaces of color.

To reach the temple, you go up. The closer you get, the more prayer wheels you find. The boys spun every wheel, sending silent mantras through the fog: Om Mani Padme Hum. Honoring the divine in everything. Gold wheels, white, painted, silver. The hands of the boys, the monks, the pilgrims touched where thousands of others had before them.

As we entered the temple complex, incense burned from large white stupas, leaving the air sweet and thick with scent. An open hall stood on one side of the complex, where monks and pilgrims knelt in lines, chanting beneath the low ceiling. Deep-voiced mantras mixed with the bright ting from prayer wheels below. On the back wall hung three long rows of framed 8 × 10 photographs. I thought they were pictures of the monks who lived in the monastery, a band of fifty or so. But they were not.

Each frame held a monk who had set himself on fire. Face after face, most of them barely twenty, smiling out at us, one in midbite, one on horseback, one in shoulder-high grass, others without pictures at all, just the black outline of a head, several engulfed in flame. Underneath each picture: name, age, and the date and place of self-immolation. Here is where they burned.

We tried to explain to the boys why someone might set himself on fire, but we stumbled.

"Sometimes," I said to them finally, "people burn."

Inside the grounds, we maintained silence and continued to walk in a clockwise direction around the temple, forever moving inward. Pilgrims stood before long wooden boards placed on the ground.

One by one, they would rise in salutation before prostrating themselves fully on the lacquered planks. Small squares of fabric allowed them to slide their bodies down. Each pilgrim would complete 108 prostrations a day, thousands upon thousands in a lifetime. Men and women, bodies crumpled and bent with age, bowed to the unfathomable, surrendering it all.

We joined them, offering our less practiced prayers. Kellen lay on the wooden pallet for a long time, his body stretched the length of the board. Then Aidan. In their long pauses, bellies to the earth, arms extended overhead, I wondered what fears they named, what they offered, how they carried all they had seen.

We left the temple in the rain. Women holding dust-covered babies pointed to their mouths and begged "milk for baby, milk for baby." A man whose body was ravaged by scars stood nearby. Toddlers sat on the ground, sucking on their fingers, while dogs roamed the streets in search of food. Aidan and I held hands as we walked down the busy road. Cars and trucks whizzed past us, honking and determined. Fog rolled through the trees, curling like waves.

"Let me get on the outside of you," I said to Aidan. "That way it will be me who gets hit."

"Please, Mom, don't say that," he responded, and he held my hand tighter. Moments earlier I noticed the way he pulled me off the road whenever a car came close. "Please don't say that, here especially, where there are so many children without parents." His voice broke in the rain.

"Okay," I answered. "It's okay, Aidan." I traded hands and stepped into the traffic, shielding him from whatever I could.

In the temple of the Dalai Lama, where pictures of those who have sacrificed their young lives adorn the walls, several monks spend the day inside a tiny room filled with lamps. Hundreds of flames flicker from small bronze pots of ghee. The monks tend the flames all day long, adding oil, relighting, twisting the wicks more tightly. The lights are meant to dispel the darkness and they never go out.

Great beauty arrives along with the difficulty in India. O'Keeffe writes in a postcard to her friend Maria Chabot, "It's a kind of

world one cannot believe is true. The largest temples we have seen just left me speechless—It is really devastating." Both beauty and pain devastate her. As does the art she sees—the paintings, the statues, the carvings: a standing Buddha that provides "the finest depiction of the dignity of man that I have ever seen"; a religious festival that is "the most spectacular thing I ever saw"; a god carried on a cart. She writes to Anita, "The religious feeling that is everywhere is all something warm that we just don't have—the eyes that meet you are gentle." By the time she reaches Bombay, from where she will visit the luminous cave carvings in Ajanta and Ellora, she has begun to set the blissful and the difficult side by side. She tells Anita about riding an elephant to a fort. "Elephant riding is a little rough and the sun a bit hot but it goes with India I suppose."

A bronze statue of Shiva Nataraja, the dancing Shiva, adorns the front of the postcard that O'Keeffe sends home to Chabot. Lord Shiva, one of the Hindu Trimurti, performs his cosmic dance to destroy the old and make way for the creation of the new. In Hindu theology, destruction is welcomed for its promise of renewal. What Westerners might shun—pain, suffering, loss—is embraced on the yogic path. The dark and the light, the harrowing and the blissful, the seen and the unseen become valued, honored, and given a place. Not unlike bones on a desert floor.

One evening, just at sunset, I left the yoga studio in McLeod Ganj and began my walk home. The leftover light shone so clear and bright on the Himalayas that my chest tightened. I have no words for that kind of beauty—I was caught off guard every time, and the mountains were delivered new to me. Rain-rinsed air. Pantheon of sky. The snowcaps held the orange-and-violet light, a communion enacted every evening. Nothing loose, extra, or stray, all just was.

On my way up to class, I had passed a sari-clad woman returning from work at one of the construction sites. She balanced a full-size pickax on her head, the flat of the steel mallet set on her scalp. She used no hands as she made her way down the steep rock-strewn trail. The ax rested perfectly on her head, and she bore it with the elegance of a crown. Her feet seemed to float just above the road, her

body long and straight, a queen. Though I imagine she was covered in dirt, her sari worn and soiled, she walked like Grace itself.

Days before, we had hiked a trail we had never been on, one that wandered deep into the woods. We passed through ancient deodar forests, the morning light dappling the ground. The trees rose straight and tall, with little competing ground cover. Their limbs grew almost perfectly horizontal from their trunks, so they seemed to be in eternal prayer, palms lifted to the sky.

The trail we walked had been there for ages. In India, centuries and millennia are possible. I saw no litter. I heard no horns. We met not a single other person on the way.

All of that beauty exists every moment of the day, whether I am there to witness it or not. The trees bend in the wind at the same moment I pass a woman on the street who has lost her nose to leprosy. The snow on the peaks gathers the setting sun at the same moment a monk lights a candle for the martyred. A woman wears an ax like a crown while a man with no legs offers a stranger some tea. It's all one piece, one strand, one thread, a trail walked for centuries.

Sometimes I wonder if the beauty of this world would be so piercing if not for the pain, or if the pain would drive so deep without the peace of the forests. I know I feel both of them in the same place in my body. And when I am truly present I can see both on the streets, in the faces of the people I pass, in the hands that reach out.

It is after her time at the caves, toward the end of her travels in India, that O'Keeffe begins to articulate just how much her world has shifted. And maybe that makes perfect sense, given the message articulated by the stone carvings at the Ellora and Ajanta Caves, carvings that celebrate Hinduism, Buddhism, and Jainism simultaneously: that disparate ideas are not to be held in tension but can actually point to the one reality. She writes that her time at the caves has given her "startling experiences . . . that shift my ways of thinking about many things." Just what things have shifted, we are once again left to guess, but one of her last letters home to Anita provides a clue.

In the final long letter she posts home, O'Keeffe tells Anita, "I must speak to you this morning . . . such things I have seen out the window I have never dreamed—this is more like my dreams than

anything I have ever seen." She is referring literally to the rivers below the plane as she flies, but one gets the sense that she is describing her entire time in Asia. She continues, "I really can't tell of it but it makes me believe in my dreams <u>more</u> than I ever have."

To fully understand the significance of these lines, it helps to return to O'Keeffe's early struggles to realize her own artistic vision. In the well-known story, O'Keeffe, living in Columbia, South Carolina, worked in the fall of 1915 to move away from what had already been done in visual art and to find her own way of seeing. She sat on the floor of her room with paper around her and only charcoal in her hand, and she stayed there until she broke through. Of course, what waited for her on the other side of those long lonely nights were the pure forms of abstraction, some of the first in the world. They were unlike anything that had ever been done, and they came from some deep inarticulate place inside her. She was unsure of what she had. She wrote to her friend Anita Pollitzer, "I wonder if I am a raving lunatic for trying to make these things." When she shared these early drawings with Stieglitz, she told him the drawings were a way "to express myself— things I feel and want to say—haven't words for—You probably know without my saying it—that I ask because I wonder if I got over to anyone what I want to say."

That was the value of abstraction for O'Keeffe: its ability to translate consciousness itself, to "get over" to another what words cannot contain. And what she finds in India in the spring of 1959—the poverty, the carvings, the gentle eyes, the unbelievable wonder of it all—resonates on the deepest of levels with O'Keeffe. They are her dreams made manifest.

I came close to getting a tattoo in India: *shanti*, peace, three times in Sanskrit down the base of my neck. McLeod Ganj had several tattoo studios. Through the open windows of one of them, I could often hear the hum of the needle. Several people always sat in chairs outside the door, waiting, perhaps, for their turn.

Sanitation did not stop me, though it did give me pause. The studios all boasted crudely lettered signs advertising their hygienic

conditions. But like the sign highlighting the swiftness of its shop's piercings—as opposed to long and slow??—I didn't trust the translation. Still, dirty needles weren't my fear.

One afternoon at our favorite café in McLeod Ganj, I shared my thoughts with Michael and the boys. We were having cappuccinos and cake under the hot sun. A tarp pulled tightly across metal rods above our heads kept us cool, though the ice cream on our cake had arrived a milky puddle.

"I'm thinking about getting a tattoo," I said as I pushed the chocolate crumbs around my plate. "Do you think I should?"

"Why?" Aidan wanted to know.

"I guess to show that I have been marked by India, that I am not the same person."

True. Part of the reason for the tattoo would be to externalize an internal change, to mark my body permanently in the ways I had been so deeply marked. But I also wanted the painful part of it, the burn on my skin, the wounding. Some kind of penance for my good fortune. A small sharing in the pain.

Aidan nodded his head and thought about my reasons. Michael, though, was all for it. "It's something you would never do. You should totally do it." He then started pondering the tattoos he might get, how we could go together.

"I don't want you to," Kellen said, his face full of worry.

"Why not?"

"Because then you would be a different mommy. And I want you to stay the same."

I could have argued with him, told him that change was the very thing I wanted to highlight, that I wasn't the same person, the same mommy, but at a moment in our family's life when underwear and Legos were the only familiar strands threading our days together, I only thought to reassure him.

"I'm the same mommy, Kellen. I will always be the same mommy for you."

We finished our cake and paid the bill; then we stepped into the road, me holding Kellen's hand and Michael holding Aidan's while the wild intensity of India swept past like an incoming tide, pulling everything with it and immersing us entirely.

It should come as no surprise that when O'Keeffe returns from India, she produces some of the purest abstractions of her career, drawings and paintings that seem reminiscent of her early work in their approach to line and form. A series of charcoals that focus on a riverine shape intersecting with a narrow bolt of lightning; two canvases devoted to blue, strong vibrant trunks of color reaching across canvas like torsos; branching, growing living forms in pinks and oranges, the colors of sunset, that seek the edge and move beyond. These works resonate with her early Specials, those thin and brooding forms conjured from her body long before she had seen the world. But it's not a return. It's a culmination of a journey begun decades before—one that can be traced in her words as well as her art and that startles us as much now as she must have been startled then. We are handed the days that she opened her eyes in the morning or closed them at night, waiting for the "dream thing I do that for me comes nearer reality than my objective kind of work."

Since returning from India, I have been felled by our great good fortune. Even before India, I was aware of our privilege relative to others living in the United States: good jobs, good insurance, no real debt, savings, the list goes on. But now our wealth stood in relation to what we experienced in India, and the comparison bordered on the incomprehensible. The width of the streets alone staggered me. Broad, grassy lawns; curbs and gutters and sidewalks; garbage cans; and a mail truck slowly making its way along its route. When the boys and I rode the city bus to the library on one of our first days home, the air conditioning brought goose bumps to my skin. As I write, in the early morning hours, my keyboard and the dog's snoring are the only sounds. It is completely, utterly, entirely silent.

But it is also utterly known. A week after we had returned, I went for a walk in our neighborhood. People were out mowing their lawns and playing with their children. I ambled the sidewalks, knowing no moped would run me down but also knowing that around the next corner more people would be mowing their lawns, more children riding their bikes. Nothing would surprise me. Nothing would undo me. Nothing would challenge my version of the

story. For the most part, I was sure to arrive home unshaken, unscathed, and whole. And that made me sad.

At some point, I will stop noticing the cleanliness of everything. And there will come a moment when the smell of pines won't greet me when I leave the house each morning to run. The shininess will wear off and Logan will go back to just being home.

But in other ways I am fairly sure that I will never live in the same country again. Though I have not inked the change onto my skin, the shifts in my heart are real and deep and permanent.

I look everywhere for the man with no legs who sat in the dirt every day and begged. He is harder to find here. The abundance of space alone makes seeing him more difficult. In India we lived pressed together in a seamless quilt of humanity. The United States has the space and the wealth to segregate the well and the sick, the weak and the strong, the rich and the needy. Still, he is here. He is in the man bent to crippling who cannot open the door to urgent care. He is in the young man on the bus muttering to himself and in the woman who comes running from the store asking us if we have seen a little girl and can we help her look. I can find him by visiting our neighbor who has been hospitalized for the past two months after her third back surgery. He even lives in my home, in the faces of my two boys, frustrated or scared or hurt, who have no words to name their feelings but only lash out. Opportunities for compassion reside not only on the streets of India. Enormous wealth hides injustices; it doesn't abolish them.

I am glad I didn't get a tattoo in India. The gesture seems feeble to me now. Does enough ink exist to capture the bright ferocity we bore witness to every day? Is there a word in English or in Sanskrit that could fasten both the grace and the pain to my skin? In the end, neither paint nor words can ever fully capture the devastation found in remaining open to the world. O'Keeffe knew this and still painted. She knew this and still wrote. Little approached her definition of success. The closest she came is when she quipped, "I really did well on that. It is almost nothing."

But words, like paint, can frame the devastation—in all its beauty and peril. They can reveal the void. Before the words are placed, the sentences written, the ropes thrown across the page, the abyss is

often not apparent. Only when sentences are strung together does the nothingness assume its boundaries. We see the van careening madly toward us, we watch our husband walk down the Jetway to the plane that will take him away, we accept a cup of tea, light a candle, hold our son's hand, and then we pick up a pelvis bone from a cow and raise it to the sun. Our wife takes her life in our living room and our husband takes photos of his naked lover on the bed. We run out of rupees to give and step to the edge of the canyon. The coyote is dead and won't get up again, while our son cries, "I have waited and waited." The setting sun throws colors not found in paint onto mountains so tall they are inhabited by gods, and the waves crash every minute of every day onto the shores of the Hawaiian Islands, even when no one stands shin-deep in water to watch.

Language creates the boundaries, frames the emptiness, fences the unsayable. Failing to plumb experience fully, it nevertheless reveals the distance necessary for the heart to cross.

Acknowledgments

I am grateful to so many who have made this project possible. First, I am thankful for the generous fellowship I was awarded by the Georgia O'Keeffe Research Center. The months I spent in the archives and at the center allowed me to finish this manuscript. I owe special thanks to Eumie Imm Stroukoff, Elizabeth Ehrnst, Tori Duggan, Carolyn Kastner, and Cody Hartley for their help, guidance, and support. Both the Mountain West Center and the College of Humanities and Social Sciences at Utah State University awarded me travel funding to visit the Beinecke Library as well as important landscapes in northern New Mexico. While I was at the Beinecke, Elizabeth Frengel was invaluable in negotiating the archive. Theresa Papanikolas helped me think about O'Keeffe's time in Hawaii. Carol Merrill generously talked with me about her days with O'Keeffe. Both Michele Morano and Karen Karbo provided me with excellent feedback and suggested ways to make the writing in this collection stronger.

I extend my gratitude to the University of New Mexico Press for publishing *Letters Like the Day* and to all the staff members who helped bring the book to fruition. I am particularly grateful to Elise McHugh, who believed in the project immediately and who shepherded me with grace through the entire process.

Closer to home, I have the great good fortune of being surrounded by many writers and friends who have provided both love

and support during the writing of this book. I am especially thankful to Charles Waugh, Ben Gunsberg, Chris Cokinos, Kathe Lison, Jen Peeples, Rona Kaufman, Richard Owen, Nancy Sowder, Star Coulbrooke, Jeannie Thomas, Alexa Sand, Rachel Middleman, Andrea Melnick, Millie Tullis, Morgan Sanford, Sherrie Mitchell, Chantel Gerfen, and Anita Sinha.

Closer still, my gratitude to my parents, Morris and Cynde Sinor. Their love and faith in me has never failed. To my two sons, Aidan and Kellen, who accompanied me on much of this journey, I give my deep admiration. Through their eyes I saw desert, canyon, sky, and bone. Loving them has proven to be the single most profound experience of "it" that my life has offered. Lastly, my enduring love and gratitude to my husband, Michael, to whom this book is dedicated. All that is beautiful and good in my life begins with him.

It seems only appropriate to end with O'Keeffe herself, who writes to Stieglitz on November 22, 1916, "Thank you is such a stupid worn-out way of saying what it ought to mean—tell me another way to say it—I can't think."

Notes

The majority of Georgia O'Keeffe's letters are held at the Alfred Stieglitz/Georgia O'Keeffe Archive, Yale Collection of American Literature, Beinecke Rare Book and Manuscript Library, Yale University. Unless otherwise noted, letters that I quote can be found there. Around two hundred letters from O'Keeffe to Alfred Stieglitz are housed at the Georgia O'Keeffe Museum Research Center in Santa Fe, New Mexico, in the collection "Letters to Alfred Stieglitz, 1933–1944, undated." When appropriate, I indicate letters coming from that archive.

In 2011 Yale University released the first of a two-volume set that will eventually contain the majority of the correspondence between O'Keeffe and Stieglitz. *My Faraway One: Selected Letters of Georgia O'Keeffe and Alfred Stieglitz* (volume 1, *1915–1933*) is edited by Sarah Greenough and beautifully done. The volume has been very helpful to me, especially in reproducing the back-and-forth conversation between O'Keeffe and Stieglitz. I am grateful for Greenough's gift.

Abbreviations

GOK	Georgia O'Keeffe	AP	Anita Pollitzer
AS	Alfred Stieglitz	AY	Anita Young
MC	Maria Chabot	JT	Jean Toomer

Epigraph

PAGE VII "At the mailbox": GOK to AS, June 22, 1946. "Letters to Alfred Stieglitz, 1933–1944, undated." Georgia O'Keeffe Museum Research Center Archives.

I find this line such a fitting way to open *Letters Like the Day* because of the two images presented. The first: a picture of O'Keeffe at the mailbox in Abiquiú, waiting to post a letter to her husband. The second: the image she creates of her world, unfurling with possibility before her. I am also drawn to this particular line because O'Keeffe pencils it in while waiting for the mail. The rest of the letter is in ink, but this line is inserted at the very top corner, scrunched and almost illegible. An apparent afterthought, it lets us know that O'Keeffe valued her letters enough, cared about them enough, that she reread them and even sometimes revised.

Letters Like the Day

PAGE 1 "found unopened—came too late": GOK to AS, July 12, 1946.

PAGE 2 "A kiss to you": GOK to AS, July 6, 1946.

PAGE 5 "We are tempted": Several writers warn against reading a personal letter as a "real" or "true" document. Linda Grasso writes, "I do not view letters as transparent documents that reveal meaning once we read them" ("Reading Published Letter Collections as Literary Texts: Maria Chabot–Georgia O'Keeffe Correspondence, 1941–1949 as a Case Study," *Legacy* 25, no. 2 [2008]: 243). William Decker cautions, "Letters do not provide transparent access to history" (*Epistolary Practices: Letter Writing in America before Telecommunications* [Chapel Hill: University of North Carolina Press, 1998], 9).

PAGE 7 "pleasure to be had": Thomas Mallon, *Yours Ever: People and Their Letters* (New York: Pantheon, 2009), 10.

PAGE 8 "a kind of gift": Simon Garfield, *To the Letter: A Celebration of the Lost Art of Letter Writing* (New York: Gotham, 2013), 97.

PAGE 10 "across the narrow neck": Garfield, *To the Letter*, 31.

PAGE 10 "treasure trove": Garfield, *To the Letter*, 32.

PAGE 10 "not written with an eye": Garfield, *To the Letter*, 43.

PAGE 10 "elegant" and "plain": Garfield, *To the Letter*, 98.

PAGE 11 "writing was clearly not a torture": Perhaps a better way to think about O'Keeffe and her relationship to letters in particular (rather than the written word more broadly) is to say that she accepted the difficulty in exchange for the pleasure. In a letter to Anita Pollitzer dated September 18, 1915, O'Keeffe writes, "Writing is just an aggravation. Still—it seems I have never enjoyed letters more than I have this summer." Clive Giboire, ed., *Lovingly, Georgia: The Complete Correspondence of Georgia O'Keeffe and Anita Pollitzer* (New York: Touchstone, 1990), 29.

PAGE 12 "good writers write": Frank and Anita Kermode, eds., The *Oxford Book of Letters* (New York: Oxford University Press, 1995), xxi.

PAGE 12 "the resources to deal": Kermode and Kermode, eds., *Oxford Book of Letters*, xxi.

PAGE 13 "That is beautiful": Wassily Kandinsky, *Concerning the Spiritual in Art, and Painting in Particular* (New York: Dover, 1977), 75.

Holes in the Sky

PAGE 17 "Words have been misused": GOK to Derek Bok, June 1973. Jack Cowart and Juan Hamilton, eds., *Georgia O'Keeffe, Art and Letters* (Washington, DC: National Gallery of Art, 1987), 270.

PAGE 17 "The usual words": GOK to Derek Bok, June 1973. Cowart and Hamilton, eds., *Georgia O'Keeffe*, 270.

PAGE 17 "I paint because": Karen Karbo, *How Georgia Became O'Keeffe: Lessons on the Art of Living* (Guilford, CT: Skirt!, 2012), 117.

PAGE 20 "The plains—the wonderful great big sky": GOK to AS, September 4, 1916.

PAGE 20 "passion for voids": Jennifer Saville, *Georgia O'Keeffe: Paintings of Hawai'i* (Honolulu, HI: Honolulu Academy of Arts, 1990), 45.

PAGE 21 "It is surprising to me": Georgia O'Keeffe, *Georgia O'Keeffe* (New York: Viking, 1976), n.p.

PAGE 23 "a plot of warm moist": GOK to JT, January 10, 1934. Jean Toomer Papers, James Weldon Johnson Collection, Beinecke Rare Book and Manuscript Library.

PAGE 23 "I feel more or less like a reed": GOK to Jean Toomer, March 5, 1934. Cowart and Hamilton, eds., *Georgia O'Keeffe*, 219.

PAGE 23 "man's destruction": O'Keeffe, *Georgia O'Keeffe*, n.p.

PAGE 25 "Words and I": GOK to AS, February 1, 1916.

PAGE 25 "departure of art": Richard Stratton, preface to *Concerning the Spiritual in Art*, Kandinsky, viii.

PAGE 25 "Nothing is less real than realism": O'Keeffe, *Georgia O'Keeffe*, n.p.

PAGE 25 "Texas was like an ocean": paraphrase of a letter from GOK to AP, September 11, 1916. Giboire, ed., *Lovingly, Georgia*, 183.

PAGE 26 "Filling a space in a beautiful way": O'Keeffe, *Georgia O'Keeffe*, n.p.

PAGE 28 "I want to go": GOK to William Howard Schubart, October 26, 1950. Cowart and Hamilton, eds., *Georgia O'Keeffe*, 255.

PAGE 30 "inexplicable. . . . into form": O'Keeffe, *Georgia O'Keeffe*, n.p.

A Walk into the Night

PAGE 31 "got over to anyone": GOK to AS, January–May 1916. Sarah Greenough dates this letter early January 1916 in *My Faraway One*.

PAGE 31 "What am I to say?": AS to GOK, January 20, 1916.

PAGE 32 "Much closer": AS to GOK, January 20, 1916.

PAGE 32 "What she could see": Karen Karbo, one of O'Keeffe's biographers, makes the point that O'Keeffe's "ownership" of certain landscapes derived from her early life on a Wisconsin farm, though Karbo also adds that Sun Prairie, Wisconsin, was "a place made for leaving." *How Georgia Became O'Keeffe*, 7.

PAGE 32 "It's such a surprise": GOK to AS, February 1, 1916.

PAGE 32 "Words and I": GOK to AS, February 1, 1916.

PAGE 32 "completely outdone": GOK to AS, February 1, 1916.

PAGE 32 "no one ever wanted": GOK to AS, October 1, 1916.

PAGE 33 "Perhaps because I am": AS to GOK, May 6, 1916.

PAGE 33 "The plains—the wonderful": GOK to AS, September 13, 1916.

PAGE 33 "The holiness of it": GOK to AP, September 11, 1916, Giboire, ed., *Lovingly, Georgia*, 183.

PAGE 33 "It is not the province": Sharyn R. Udall, *O'Keeffe and Texas* (San Antonio, TX: Marion Koogler McNary Art Museum, 1998), 21.

PAGE 33 "You are more the size": GOK to AS, September 3, 1916.

PAGE 34 "The letters have been": GOK to AS, September 20, 1916.

PAGE 34 "to write indoors": AS to GOK, September 20, 1916.

PAGE 34 "Isn't dark curious": GOK to AS, September 26, 1916.

PAGE 34 "to touch someone I like": GOK to AS, September 26, 1916.

PAGE 34 "understanding": AS to GOK, September 30, 1916.

PAGE 34 "Please don't—for a while": GOK to AS, September 26, 1916.

PAGE 34 "It's a great privilege": AS to GOK, September 20, 1916.

PAGE 34 "like too much light": GOK to AP, September 1916. Giboire, ed., *Lovingly, Georgia*, 201.

PAGE 35 "They are as much": GOK to AS, July 25, 1916.

PAGE 35 "all the powers": AS to GOK, September 20, 1916.

PAGE 35 "It is a burning": On a wall hanging found at the Panhandle Plains Historical Museum in Canyon, Texas.

PAGE 35 "slit in the ground": GOK to AS, December 10, 1916.

PAGE 35 "I haven't any words": GOK to AS, October 9, 1916.

PAGE 35 "Way off on the edge": GOK to AS, March 11, 1917.

PAGE 35 "Merciless": GOK to AS, March 11, 1917.

PAGE 35 "I feel it's a pity": GOK to AS, September 3, 1916.

PAGE 36 "I feel like such": GOK to AS, April 29, 1917.

PAGE 36 "in a pen": GOK to AS, October 15, 1916.

PAGE 36 "I'm getting to like you": GOK to AS, November 4, 1916.

PAGE 36 "something I want": GOK to AS, March 11, 1916.

PAGE 36 "How I understand": AS to GOK, November 4, 1916.

PAGE 36 "& I saw your hand": AS to GOK, November 5, 1916.

PAGE 36 "You are a very, very": AS to GOK, November 4, 1916.

PAGE 36 "very big—and dark": GOK to AS, November 12, 1916.

PAGE 37 "always objected to": GOK to AS, November 13, 1916.

PAGE 37 "I love it": GOK to AS, December 10, 1916.

PAGE 37 "I wanted to walk": GOK to AS, November 13, 1916.

PAGE 37 "I feel rough": GOK to AS, December 10, 1916.

PAGE 37 "I wanted you—": GOK to AS, January 10, 1917.

PAGE 37 "very alive in there": AS to GOK, January 16, 1917.

PAGE 37 "I went to bed": AS to GOK, February 6, 1917.

PAGE 37 "And I can't read": GOK to AS, February 10, 1917.

PAGE 37 "I'd like to be": GOK to AS, February 16, 1917.

PAGE 38 "More—I want—": GOK to AS, March 15, 1917.

PAGE 38 "You get it without": GOK to AS, December 21, 1916.

PAGE 38 "You feel the way": AS to GOK, April 2, 1917.

PAGE 38 "the world is entitled": AS to GOK, March 31, 1917.

PAGE 38 "I felt as if you": AS to GOK, April 10, 1917.

PAGE 38 "What are you to me": GOK to AS, April 14, 1917.

PAGE 38 "What's the use": GOK to AS, April 24, 1917.

PAGE 39 "It was him": GOK to AP, June 20, 1917. Giboire, ed.,
 Lovingly, Georgia, 255.

PAGE 39 "How I wanted": AS to GOK, June 1, 1917.

PAGE 39 "I'm sitting here": AS to GOK, June 1, 1917.

PAGE 40 "And I wish you": GOK to AS, July 1, 1917.

PAGE 40 "instead of just": GOK to AS, July 2, 1917.

PAGE 40 "Somehow I'm yearning": AS to GOK, July 2, 1917.

PAGE 40 "breasts—near my": AS to GOK, July 28, 1917.

PAGE 40 "breasts close to": GOK to AS, July 13, 1917.

PAGE 40 "It's something very": GOK to AS, October 26, 1916.

PAGE 40 "I hate it here": GOK to AS, October 18, 1917.

PAGE 40 "As you feel as if": AS to GOK, November 2, 1917.

PAGE 40 "Help me": GOK to AS, December 7, 1917.

PAGE 40 "I'm mad enough": GOK to AS, January 2, 1918.

PAGE 41 "Here I'm again": AS to GOK, January 12, 1918.

PAGE 41 "I love you very much": GOK to AS, January 20, 1918.

PAGE 41 "I had just come from": AS to GOK, October 23, 1917.

PAGE 41 "The country is really": GOK to AS, October 1, 1917.

PAGE 41 "You see, I haven't": GOK to AS, January 23, 1918.

PAGE 42 "Again I felt like": AS to GOK, January 9, 1918.

PAGE 42 "I am so very": GOK to AS, February 11, 1918.

PAGE 42 "Today I tried": AS to GOK, March 31, 1918.

PAGE 42 "I dreamt I awoke": AS to GOK, May 1, 1918.

PAGE 42 "I need you": AS to GOK, May 14, 1918.

PAGE 42 "Sometimes I feel": AS to GOK, May 26, 1918.

PAGE 42 "Haven't written": GOK to AS, April 26, 1918.

PAGE 42 "fly into a million": GOK to AS, April 26, 1918.

PAGE 43 "I'm getting to want": GOK to AS, April 30, 1918.

PAGE 43 "It has to be that": GOK to AS, June 3, 1918.

PAGE 43 "throw light into": Alfred Stieglitz, *Georgia O'Keeffe: A Portrait* (New York: Metropolitan Museum of Art, 1997), n.p.

PAGE 43 "with a kind of heat": Stieglitz, *Georgia O'Keeffe*, n.p.

PAGE 44 "Can I stand it": GOK to AS, June 14, 1918.

More Feeling Than Brain

PAGE 45 "Did you ever": GOK to AP, December 13, 1915. Giboire, ed., *Lovingly, Georgia*, 103.

PAGE 46 "You see the thing I write": GOK to AS, September 9, 1923.

PAGE 47 "My old sense": GOK to Jean Toomer, March 5, 1934. Cowart and Hamilton, eds., *Georgia O'Keeffe*, 215.

PAGE 48 "The large white flower": GOK to William Milliken, curator of painting at the Cleveland Museum of Art, November 1, 1930, as quoted in Greenough, ed., *My Faraway One*, 740.

PAGE 49 "for the world hurts": GOK to AS, April 19, 1917.

PAGE 49 "you alone know your": GOK to AS, April 3, 1943. "Letters to Alfred Stieglitz, 1933–1944, undated."

PAGE 50 "The light green waves": GOK to AS, September 23, 1923.

PAGE 51 "Today is harder": GOK to AS, May 6, 1922.

PAGE 51 "But the living truth": AS to GOK, January 22, 1918.

PAGE 52 "I wish I could do": GOK to AS, June 14, 1929.

PAGE 53 "The earth is so richly": GOK to AS, August 29, 1934.

PAGE 53 "Maybe I should try and paint": GOK to AS, August 8, 1994. "Letters to Alfred Stieglitz, 1933–1944, undated."

PAGE 54 "It is sometimes saying": GOK to AS, March 14, 1918.

PAGE 55 "I have used these things": Georgia O'Keeffe, *Georgia O'Keeffe: Some Memories of Drawings*, ed. Doris Bry (Albuquerque: University of New Mexico Press, 1974), n.p.

PAGE 56 "This is a drawing": O'Keeffe, *Georgia O'Keeffe: Some Memories of Drawings*, n.p.

PAGE 56 "I work in a queer": GOK to AS, March 14, 1918.

PAGE 57 "I will probably": GOK to AS, July 27, 1928.

PAGE 59 "I feel like bursting": GOK to AS, April 30, 1929.

PAGE 59 "Even through my tears": GOK to AS, April 27, 1929.

PAGE 59 "turning the world": GOK to AS, May 10, 1929.

PAGE 60 "It is as though": GOK to AS, May 3, 1929.

PAGE 62 "went into the farthest . . . brightest star": Stieglitz, *Georgia O'Keeffe*, n.p.

PAGE 62 "Things go on in me": GOK to AS, May 20, 1929.

PAGE 62 "I actually began a letter": AS to GOK, May 25, 1929.

PAGE 63 "Bandaged": AS to GOK, June 21, 1929.

PAGE 63 "I seem to be hunting": GOK to AS, May 30, 1929.

PAGE 63 "The mountains and the": GOK to AS, June 14, 1929.

PAGE 63 "lie down in the sun": GOK to AS, May 30, 1929.

PAGE 63 "Dead in every way": AS to GOK, June 6, 1929.

PAGE 63 "I have already lived": AS to GOK, June 6, 1929.

PAGE 64 "My Holy Mountain": AS to GOK, June 8, 1929.

PAGE 64 "the sort of day": GOK to AS, June 13, 1929.

PAGE 64 "This seems to be my world": GOK to AS, June 14, 1929.

PAGE 64 "I can't go into it": GOK to AS, May 4, 1929.

PAGE 64 "I can really only": GOK to AS, June 13, 1929.

PAGE 64 "touches something": GOK to AS, June 15, 1929.

PAGE 65 "My Sweetest heart": AS to GOK, May 9, 1929.

PAGE 65 "dead useless thing": AS to GOK, June 21, 1929.

PAGE 65 "not even dead": AS to GOK, June 21, 1929.

PAGE 65 "A marvelous yellow": AS to GOK, June 24, 1929.

PAGE 65 "feeling remarkably": GOK to AS, June 24, 1929.

PAGE 65 "There is nothing": GOK to AS, June 17, 1929.

PAGE 66 "Something hot, dark and destructive": Stieglitz, *Georgia O'Keeffe*, n.p.

PAGE 66 "the blue and white": AS to GOK, June 27, 1929.

PAGE 66 "I must assume": AS to GOK, June 27, 1929.

PAGE 66 "What I feel you": GOK to AS, June 30, 1929.

PAGE 67 "With things moving": GOK to AS, July 2, 1929.

PAGE 67 "So we are quite": GOK to AS, July 2, 1929.

PAGE 67 "—Now that is": GOK to AS, July 2, 1929.

PAGE 67 "the next best thing": GOK to AS, May 30, 1929.

PAGE 67 "You really do not": AS to GOK, July 6, 1929.

PAGE 67 "I cannot live this": AS to GOK, July 5, 1929.

PAGE 68 "I am not writing": AS to GOK, July 1, 1929.

PAGE 69 "You don't feel": AS to GOK, July 4, 1929.

PAGE 69 "So little light": AS to GOK, July 4, 1929.

PAGE 69 "There is no escape": AS to GOK, July 4, 1929.

PAGE 69 "I ask for little": AS to GOK, July 5, 1929.

PAGE 69 "Without you I": AS to GOK, July 6, 1929.

PAGE 69 "Well, I am sorry": GOK to AS, July 6, 1929.

PAGE 69 "a bit mad": GOK to AS, July 6, 1929.

PAGE 69 "But I did": GOK to AS, July 6, 1929.

PAGE 69 "I don't need to see": AS to GOK, July 7, 1929.

PAGE 70 "All I have to say": GOK to AS, July 6, 1929.

PAGE 71 "You really need to": GOK to AS, July 7, 1929.

PAGE 71 "Months and years": GOK to AS, July 11, 1929.

PAGE 71 "An untouched whiteness": GOK to AS, July 11, 1929.

PAGE 72 "there is a bond . . . choose it or not": GOK to AS, July 12,
 1929.

PAGE 72 "You have a new vision": AS to GOK, July 14, 1929.

PAGE 72 "If you had no reputation": AS to GOK, July 14, 1929.

PAGE 73 "The stars over your": AS to GOK, July 20, 1929.

PAGE 73 "As I read your letters": GOK to AS, July 21, 1929.

PAGE 73 "I gave up myself": GOK to AS, July 24, 1929.

PAGE 73 "things in me": GOK to AS, August 1, 1929.

PAGE 73 "cannot hurt [you]": GOK to AS, July 24, 1929.

PAGE 73 "unfit to have any": AS to GOK, July 14, 1929.

PAGE 73 "As long as you": AS to GOK, July 14, 1929.

PAGE 74 "If you ever receive": AS to GOK, August 18, 1929.

Taking Myself to the Sun

PAGE 75 "Taking myself to the sun": GOK to JT, March 5, 1934.
 Jean Toomer Papers.

PAGE 76 "When I make a photograph": quoted in Roxana Robin-
 son, *Georgia O'Keeffe: A Life* (New York: Harper & Row,
 1989), 251.

PAGE 77 "nobody—nowhere": GOK to AS, August 20, 1926.

PAGE 77 "A black ugly wall": AS to GOK, September 3, 1926.

PAGE 77 "I know I am always": AS to GOK, August 22, 1926.

PAGE 77 "I also know that as far": AS to GOK, August 29, 1926.

PAGE 77 "such masses of froth": GOK to AS, May 6, 1922.

PAGE 77 "that the ocean gives": GOK to AS, August 26, 1926.

PAGE 77 "It must be because": GOK to AS, September 22, 1926.

PAGE 79 "into something from which": GOK to AS, May 3, 1929.

PAGE 79 "leave your regrets": GOK to AS, July 9, 1929.

PAGE 81 "battlefield terribly torn": GOK to AS, October 24, 1931.

PAGE 81 "You see—there isn't": GOK to AS, July 18, 1934.

PAGE 82 "I feel like nothing": GOK to AS, May 27, 1933.

PAGE 82 "Nothing in me": GOK to AS, November 6, 1933.

PAGE 82 "I am only vacancy": GOK to AS, July 5, 1934.

PAGE 83 "the salvation of man": Viktor E. Frankl, *Man's Search for Meaning* (Boston, MA: Beacon Press, 2014), 35.

PAGE 83 "pigs": Frankl, *Man's Search for Meaning*, 36.

PAGE 84 "Nothing . . . could touch the strength": Frankl, *Man's Search for Meaning*, 37.

PAGE 84 "know bliss": Frankl, *Man's Search for Meaning*, 35.

PAGE 84 "Set me like a seal": Frankl, *Man's Search for Meaning*, 37.

PAGE 85 "unable to find words for": GOK to AP, December 2015. Giboire, ed., *Lovingly, Georgia*, 103.

PAGE 85 "sheltered against each": Robinson, *Georgia O'Keeffe*, 395.

PAGE 85 "to life": GOK to JT, January 3, 1934. Jean Toomer Papers.

PAGE 85 "You seem to have given me": GOK to JT, January 3, 1934. Jean Toomer Papers.

PAGE 86 "add unto yourself": JT GOK, January 21, 1934.

PAGE 86 "let them flow": JT to GOK, January 21, 1934.

PAGE 88 "Maybe I love her too much": GOK to JT, January 3, 1934. Cowart and Hamilton, eds., *Georgia O'Keeffe*, 216.

PAGE 88 "—There are paintings": GOK to JT, February 8, 1934. Cowart and Hamilton, eds., *Georgia O'Keeffe*, 218.

PAGE 88 "raw and torn": Cowart and Hamilton, eds., *Georgia O'Keeffe*, 218.

Perfectly Fantastic

PAGE 93 "Here I am": GOK to AS, February 10, 1939.

PAGE 93 "mass production": Saville, *Georgia O'Keeffe*, 15.

PAGE 94 "Pineapples": GOK to AS, April 3, 1939.

PAGE 94 "dumb": GOK to AS, February 23, 1939.

PAGE 94 "all sharp and silvery": *Art Digest* 17, no. 1 (March 1, 1943).

PAGE 94 "Nobody sees a flower": O'Keeffe, *Georgia O'Keeffe*, n.p.

PAGE 95 "single track mind": O'Keeffe, *Georgia O'Keeffe*, n.p.

PAGE 95 "get under [her] skin": GOK to AS, March 18–20, 1939.

PAGE 96 "this collection all testify": quoted in Hunter Drohojowska-Philip, *Full Bloom: The Art and Life of Georgia O'Keeffe* (New York: Norton, 2004), 385.

PAGE 96 "the overpowering stimuli": Laurie Lisle, *Portrait of an Artist: A Biography of Georgia O'Keeffe* (Albuquerque: University of New Mexico Press, 1986), 244.

PAGE 96 "The shade is sort": GOK to AS, February 10, 1939.

PAGE 97 "flowers strung together": GOK to AS, February 10, 1939.

PAGE 97 "at the things": GOK to AS, February 10, 1939.

PAGE 97 "I must get painting": GOK to AS, February 10, 1939.

PAGE 97 "I hope I can put": GOK to AS, February 10, 1939.

PAGE 97 "soft . . . wrinkled": GOK to AS, February 10, 1939.

PAGE 97 "nice as such things": GOK to AS, February 10, 1939.

PAGE 97 "queer scraps of flower": GOK to AS, February 12, 1939.

PAGE 98 "perfectly fantastic . . . unbelievable": GOK to AS, February 15–17, 1939.

PAGE 98 "be still": GOK to AS, February 12, 1939.

PAGE 98 "going to stop going": GOK to AS, February 15–17, 1939.

PAGE 98 "struggle": GOK to AS, February 19–21, 1939.

PAGE 98 "carries over": personal interview with Theresa Papanikolas, July 2, 2012, Honolulu, Hawaii.

PAGE 98 "Jennifer Saville, the curator": Saville, *Georgia O'Keeffe*, 25–31.

PAGE 99 "a waste of time": GOK to AS, February 23, 1939.

PAGE 99 "the others—oh dear": GOK to AS, February 23, 1939.

PAGE 99 "and again I say": GOK to AS, February 23, 1939.

PAGE 99 "It is difficult": GOK to AS, February 23, 1939.

PAGE 99 "I wish I could see": GOK to AS, February 23, 1939.

PAGE 99 "handsome . . . old ivory": GOK to AS, February 23, 1939.

PAGE 99 "Many things are so": GOK to AS, February 26, 1939.

PAGE 100 "dull": GOK to AS, February 26, 1939.

PAGE 100 "Considering what": GOK to AS, February 26, 1939.

PAGE 100 "I'm going to drive": GOK to AS, February 26, 1939.

PAGE 100 "This seems to be the best yet": postcard from GOK to AS, March 10, 1939.

PAGE 100 "like a dream": GOK to AS, March 13, 1939.

PAGE 100 "The foliage changes, GOK to AS, March 13, 1939.

PAGE 100 "I don't know whether I can . . . what is here": GOK to AS, March 13, 1939.

PAGE 101 "really quite good": GOK to AS, March 18–20, 1939.

PAGE 101 "getting sure on": GOK to AS, March 20, 1939.
PAGE 101 "floats out there in the": GOK to AS, March 23–24, 1939.
PAGE 101 "With my station wagon": GOK to AS, March 25–27, 1939.
PAGE 102 "more time to work": GOK to AS, March 31, 1939.
PAGE 102 "I just begin to be clear": GOK to AS, March 31, 1939.
PAGE 102 "the kind of color": GOK to AS, March 31, 1939.
PAGE 102 "even rare here": GOK to AS, March 31, 1939.
PAGE 102 "disgusted . . . pretty good": GOK to AS, April 3, 1939.
PAGE 102 "lovely": GOK to AS, April 5–9, 1939.
PAGE 102 "I just suddenly think": GOK to AS, April 5–9, 1939.
PAGE 102 "You make me see": GOK to AS, April 10, 1939.

Spiral

PAGE 105 "I took my chances": Jack Flan, ed., *Robert Smithson: The Collected Writings* (Oakland: University of California Press, 1996), 148.
PAGE 106 "mile of elephants": O'Keeffe, *Georgia O'Keeffe*, n.p.
PAGE 108 "—I painted two days": GOK to AS, November 7, 1941. "Letters to Alfred Stieglitz, 1933–1944, undated."
PAGE 109 "a place that I love": Barbara Buhler Lynes, ed., *Georgia O'Keeffe: Catalogue Raisonné* (New Haven, CT: Yale University Press, 1999), 643.
PAGE 109 "Good Morning from": GOK to AS, November 10, 1941. "Letters to Alfred Stieglitz, 1933–1944, undated."
PAGE 111 "was painted in summer": Lynes, ed., *Georgia O'Keeffe*, 664.
PAGE 111 "Everything must be done": GOK to AS, July 20, 1943. "Letters to Alfred Stieglitz, 1933–1944, undated."
PAGE 112 "dozens of selves": GOK to AS, May 6, 1922.
PAGE 112 "the most joyful": Flan, ed., *Robert Smithson*, 144.
PAGE 113 "Up before the sun . . . including us": GOK to AS, October 19–20, 1943. "Letters to Alfred Stieglitz, 1933–1944, undated."
PAGE 113 "It was as dismal. . . . loved it": GOK to AS, October 19–20, 1943. "Letters to Alfred Stieglitz, 1933–1944, undated."
PAGE 114 "gyrating space": Flan, ed., *Robert Smithson*, 146.

PAGE 114 "bleeding scarlet": Flan, ed., *Robert Smithson*, 148.
PAGE 114 "The shore of the lake": Flan, ed., *Robert Smithson*, 146.
PAGE 114 "Following this spiral steps ... primordial sea": Flan, ed.,
 Robert Smithson, 148.
PAGE 115 "clad in a glistening": Jennifer L. Roberts, "The Taste of
 Time: Salt and Spiral Jetty," in *Robert Smithson*, ed.
 Eugenie Tsai (Oakland: University of California Press,
 2004), 97.
PAGE 115 "Out where I was": GOK to AS, August 18, 1943. "Letters
 to Alfred Stieglitz, 1933–1944, undated."
PAGE 115 "It is so unbelievable": GOK to AS, August 18, 1943.
 "Letters to Alfred Stieglitz, 1933–1944, undated."
PAGE 116 "When I see the country": GOK to AS, August 18, 1943.
 "Letters to Alfred Stieglitz, 1933–1944, undated."
PAGE 116 "Her landscapes often feel uninhabited": O'Keeffe once
 said, "I've always believed I can get all that into a picture
 by suggestion. I mean the life that has been lived in a
 place." Daniel Catton Rich, *Georgia O'Keeffe* (Chicago,
 IL: Art Institute of Chicago, 1943), 29.
PAGE 116 "He has been at the very center": O'Keeffe knows that
 Stieglitz is fading. She writes to Chabot in 1941 that he
 is "a person gradually becoming less and less and there
 is nothing I can do." GOK to MC, May 8, 1941. Barbara
 Buhler Lynes and Ann Paden, eds., *Maria Chabot-
 Georgia O'Keeffe Correspondence, 1941–1949* (Albu-
 querque: University of New Mexico Press, 2003), 27.
PAGE 117 "The world is so much": GOK to AS, August 18, 1943.
PAGE 117 "Georgia's country ... why all of us are here": MC to AS.
 Lynes and Paden, eds., *Maria Chabot-Georgia O'Keeffe
 Correspondence*, 193.
PAGE 118 "One seizes the spiral": Flan, ed., *Robert Smithson*, 147.
PAGE 118 "Have you climbed?": All quotations from *Georgia
 O'Keeffe*, a 1977 documentary film produced by Perry
 Miller Adato.
PAGE 118 "freed her into": Christine Taylor Patten and Alvaro
 Cardona-Hine, *Miss O'Keeffe* (Albuquerque: University
 of New Mexico Press, 1992), 24.
PAGE 119 "If whatever I painted": Patten and Cardona-Hine, *Miss
 O'Keeffe*, 127.

PAGE 121 "astonishing things": GOK to AY, April 13, 1959.

PAGE 121 "Will you keep": GOK to AY, March 1, 1959.

PAGE 125 "They were wonderful": GOK to AY, February 11, 1959.

PAGE 125 "More—I want—": GOK to AS, March 15, 1917.

PAGE 126 "It seems that": GOK to AY, March 15, 1959.

PAGE 127 "I feel I have been on top": GOK to AY, March 15, 1959.

PAGE 127 "All these places are dirty": GOK to AY, March 15, 1959.

PAGE 127 "there were harrowing": GOK to AY, March 15, 1959.

PAGE 129 "It's a kind": GOK to MC, March 4, 1959. "Letters to Alfred Stieglitz, 1933–1944, undated."

PAGE 130 "the finest depiction": GOK to AY, March 23, 1959.

PAGE 130 "the most spectacular": GOK to AY, April 13, 1959.

PAGE 130 "The religious feeling": GOK to AY, March 15, 1959.

PAGE 130 "Elephant riding": GOK to AY, April 13, 1959.

PAGE 131 "startling experiences": GOK to AY, April 13, 1959.

PAGE 131 "I must speak to you": GOK to AY, April 25, 1959.

PAGE 132 "I wonder if I am a raving": GOK to AP, December 1915. Giboire, ed., *Lovingly, Georgia*, 103.

PAGE 132 "to express myself": GOK to AS, January–May 1916. Sarah Greenough dates this letter early January 1916 in *My Faraway One*.

PAGE 134 "dream thing I do": GOK to Dorothy Brett, February 1932. Cowart and Hamilton, eds., *Georgia O'Keeffe*, 205.

PAGE 135 "I really did well on that": Charlotte Willard, "Portrait: Georgia O'Keeffe," *Art in America* 51 (Oct. 1963): 95.